PRACTICAL ART

DRAWING

A STEP-BY-STEP GUIDE TO DRAWING TECHNIQUES

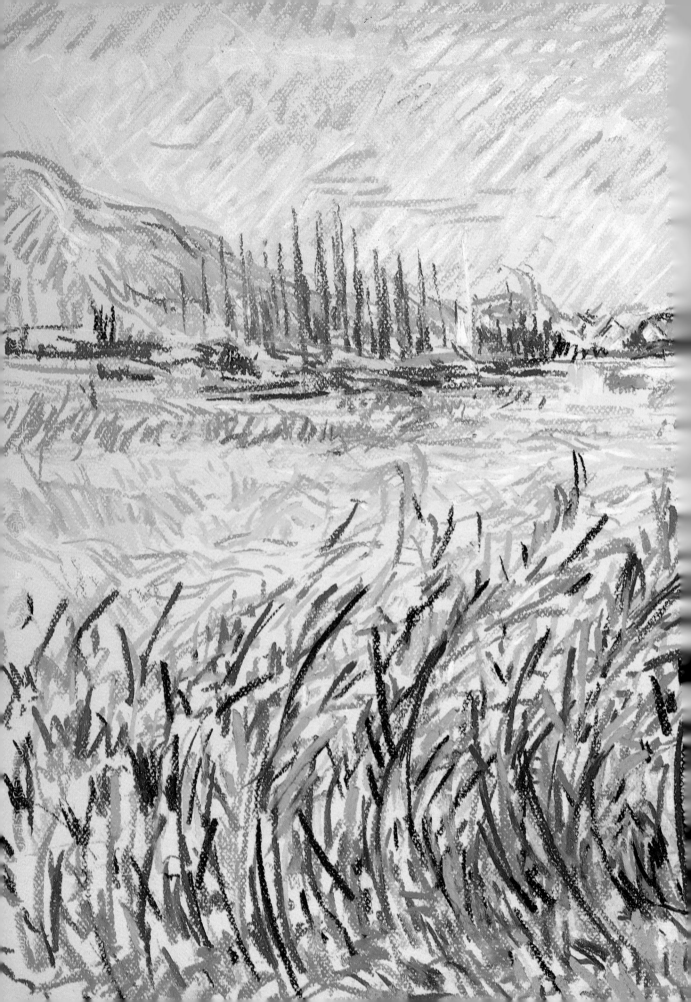

PRACTICAL ART

DRAWING

A STEP-BY-STEP GUIDE TO
DRAWING TECHNIQUES

ANGELA GAIR

TIGER BOOKS
INTERNATIONAL
LONDON

First published in 1994
by Letts of London
an imprint of New Holland (Publishers) Ltd
London · Cape Town · Sydney · Singapore

24 Nutford Place
London W1H 6DQ
United Kingdom

80 McKenzie Street
Cape Town 8001
South Africa

3/2 Aquatic Drive
Frenchs Forest, NSW 2086
Australia

Reprinted 1995

This edition published in 1997 by Tiger Books International Plc,
Twickenham

ISBN 1 85501 868 3

Copyright © 1994 New Holland (Publishers) Ltd

A CIP catalogue record for this book is available from the British Library

Editorial Director: Joanna Lorenz
Project Editor: Judith Simons
Designed and Typeset by: Axis Design
Photographer: Ken Grundy

Reproduction by J Film Process (S) Pte Ltd
Printed and bound in Malaysia by Times Offset (M) Sdn Bhd

ACKNOWLEDGEMENTS
Special thanks are due to Winsor & Newton, Whitefriars Avenue, Harrow,
Middlesex, for providing the materials and equipment featured and used in
this book; Sean Kelly Gallery, 21 London Road, London, for supplying
additional materials; Llewellyn-Alexander Gallery, London; and
Annie Wood for her invaluable help.

CONTENTS

INTRODUCTION

Drawing is one of the most elementary of human activities. Its origins go back to the beginning of recorded history, when man began to depict hunting scenes on the walls of caves with charcoal outlines coloured with earth pigments. The ancient Egyptians used pens made of sharpened reeds and ink made of powdered earth to draw hieroglyphics – pictures representing words – on sheets of papyrus. But these early drawings were stylized and served a purely symbolic purpose.

It was not until the Greek classical period, in the fifth century BC, that artists began to make realistic representations of nature and to devise the classical concepts of proportion, space and

Dancer *Edgar Degas*

This pastel and charcoal study of a ballet dancer has an immediacy which captures the essence of a fleeting pose. The vigorous, sweeping strokes and the various visible alterations describe not only the grace and beauty of the dancer's stance but the general feeling of movement in her body. Charcoal and pastel are sympathetic drawing media, responding immediately to the artist's impulse.

Sketch of a Nude Man *Michelangelo Buonarotti*

A sculptor, painter and architect, Michelangelo was one of the greatest artists of the Renaissance. Although incomplete, this drawing in pen and bistre ink shows his mastery of human anatomy. The muscles of the male torso are accurately represented and drawn with force and vigour using the technique of hatching and crosshatching to give a powerful statement of form and volume.

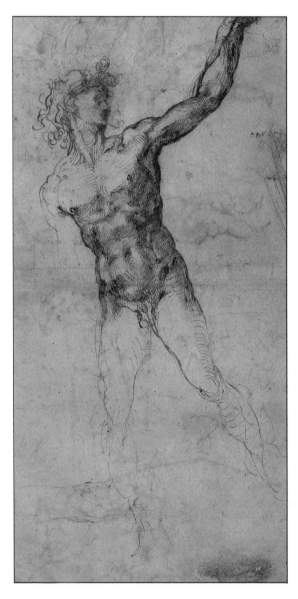

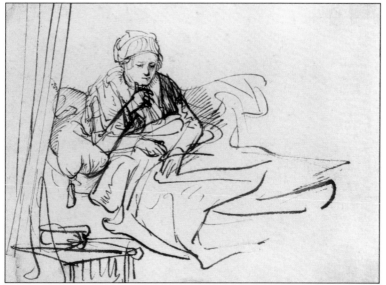

Saskia in Bed
Rembrandt van Rijn

This is one of a number of drawings which Rembrandt made of his wife Saskia in bed during the long illness that led to her death. Even in a rapid sketch like this one, Rembrandt's mastery of the pen-and-ink line is evident; with a few whiplash strokes he manages not only to convey a wealth of detail but, on a deeper level, to suggest his own emotional response to his subject.

volume that still have a strong influence on art in the present day.

During the Middle Ages, artists worked in the service of the Christian church which decreed that there should be no graven images, so realistic representation was once more replaced by stylized and symbolic images. However, all this changed with the flowering of the Renaissance between the fourteenth and sixteenth centuries. The term Renaissance means "rebirth", and the new era saw the narrow, superstitious beliefs of the Middle Ages give way to a resurgence of interest in the classical ideals of Greek and Roman art. Drawing became established as the foundation of training in the arts. Anatomy, proportion and the science of perspective (the technique of giving an illusion of three-dimensional space on a flat, two-dimensional surface) were studied, and apprentices were encouraged to draw directly from nature as well as copying from the drawings of their masters.

This explosion of artistic activity was matched by an increasing variety of drawing media. Charcoal and chalk were used for making large studies and cartoons for larger, commissioned paintings. Silverpoint – the precursor of the graphite pencil – was used to make smaller, carefully executed drawings used as prepara-tory studies for paintings and sculptures. The silverpoint stylus was a silver wire set into a wooden handle, which made delicate silver-grey lines on paper coated with gesso or chalk. Pen and ink drawings were executed on beautifully tinted papers, often highlighted with white chalk. From this period there emerged some of the world's greatest artists, among them Leonardo da Vinci (1452–1519), Michelangelo (1475–1564), Raphael (1483–1520), Albrecht Dürer (1471–1528) and Hans Holbein (1497–1543).

During the early Renaissance (the early fifteenth century) drawings were precise and linear in style, with the emphasis on the exact character of surface detail. But by the time of the High Renaissance (late fifteenth and early sixteenth centuries) drawing had become looser in style and surface detail was suggested rather than rendered with precision. The edges of forms became softened and broken and a feeling for light, space and air was more evident.

By the seventeenth century drawing had at last become valued as a form of artistic expression in its own right rather than a mere adjunct to painting. The methodical use of hatched and crosshatched lines to build up dark tones, used by the Renaissance artists, gave way to a new freedom and vigour of execution and a greater

use of dramatic chiaroscuro (contrasts of light and dark). Holland produced several artists of genius, most notably Rembrandt (1606–1669) and Claude Lorrain (1600–1682), both of whom produced superb drawings in pen and ink or brush and wash.

During the eighteenth century, France became the chief centre of artistic innovation. The invention of the graphite pencil helped to make drawing even more popular by enabling fine lines and shading to be achieved without the inconvenience of using ink. Antoine Watteau (1684–1721) drew with a light, delicate touch that expressed the rococo ideals of grace, charm and courtly sophistication. Pastel also became a popular medium at this time, its greatest exponents being Rosalba Carriera (1674–1757), Jean-Baptiste Chardin (1699–1779) and Quentin de la Tour (1704–1788).

The classical revival dominated the first part of the nineteenth century in France. Jean Auguste Dominique Ingres (1780–1867), arguably the greatest draftsman of his age, produced many portrait and figure studies in pencil. His technical virtuosity was astounding and his beautifully wrought figure and portrait studies were the result of years of painstaking study and disciplined observation. Ingres told his pupils that the technique of painting could be mastered in a week, but the study of drawing demanded a lifetime.

By the middle of the century, however, some French artists began to break away from the strict confines of Classicism. Eugène Delacroix (1798–1863) was the leader of the Romantic movement; his pen and ink drawings are charged with energy, the writhing, turbulent lines moving freely to describe his emotional reaction to his subject. Honoré Daumier (1808–1879) belonged to the Realist group of painters who rejected grandiose historical themes and portrayed ordinary life around them. Daumier drew people with humour, satire and sympathy, using charcoal and pen and ink with an economy and fluidity of line that accentuates the sharpness of his observation.

The most striking characteristic of twentieth-century drawing is its diversity of style and expression. Just some of the artists worth studying are Pablo Picasso (1881–1973), whose prodigious output encompassed many styles, subjects and techniques; Henri Matisse (1869–1954), whose use of eloquent calligraphic lines is breathtaking beautiful; Giorgio Morandi (1890–1964), who achieved incredible subtleties of light and shade with patiently hatched and crosshatched lines; and David Hockney (born 1937), whose influence has raised the status of the coloured pencil from child's drawing tool to a major drawing medium.

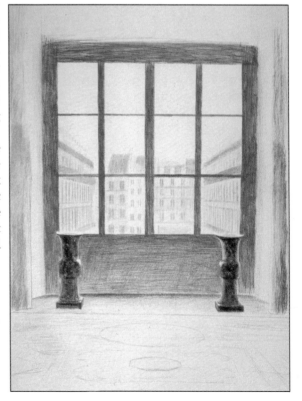

Coloured Drawing, Paris '73 *David Hockney*

The quiet restraint of this interior scene stems from the subdued colours and static composition. Hockney has used coloured pencils to create layers of hatched and crosshatched marks woven into mixed hues and tones. Much of the current popularity of coloured pencil is due to Hockney's work in the medium.

MATERIALS AND EQUIPMENT

There is an almost overwhelming variety of drawing materials available to the artist today, and new ones are being developed all the time. In this section the main categories of drawing media are described and illustrated.

PENCILS

Graphite pencils are graded by the H and B systems, according to the relative hardness or softness of the graphite core. Hard pencils range from 9H (the hardest) to H. Soft pencils

Pencils can be used both to produce a quick study or to create a finely detailed drawing. Several pencils, in a range of soft and hard leads, were used to achieve the subtle tones in this still-life drawing.

range from 8B (the softest) to B. HB is midway between hard and soft and is good for everyday use. A very soft lead enables you to make broad, soft lines, while hard leads are suited to fine lines and precise details. A medium grade such as 2B or 3B is probably the most popular for drawing.

Extremely soft pencils, known as graphite sticks, are also available. These are quite thick and produce strong, dark marks that are especially effective on rough-textured paper.

CHARCOAL

Stick charcoal is made from vine or willow twigs charred in special kilns and is available in various thicknesses. Thin sticks are suitable for sketches and delicate, detailed work.

Thicker ones are better for bold work and for covering large areas quickly. Soft charcoal is powdery and smudges easily, so use it with care and protect the finished drawing with spray fixative (see page 15).

PASTELS

Pastels are made from finely ground pigments bound together with gum to form a stiff paste, which is then shaped into sticks and allowed to harden. Four main types are available:

Soft pastels are the most widely used of the various types because they produce the wonderful velvety bloom which is one of the main attractions of pastel art. They contain more pigment and less binder, so the colours are vibrant. The

smooth, thick quality of soft pastels produces rich, painterly effects. They are easy to apply, requiring little pressure to make a mark, and can be blended and smudged with a finger, a rag, or a paper stump (torchon).

Hard pastels contain less pigment and more binder than the soft type. Although they have a firmer consistency, the colours are less brilliant. Hard pastels can be sharpened to a point with a blade and used for crisp lines and details. Unlike soft pastels, they do not crumble and break easily, nor do they clog the tooth of the paper, so they are often used in the preliminary stages of a drawing to outline the composition, or for adding details and accents at the end.

Pastel pencils are thin pastel sticks encased in wood, like ordinary pencils. They are clean to use, do not break or crumble as traditional pastels do, and give greater control of handling. Pastel pencils are perfect for line sketches and detailed small-scale work, and can be used in conjunction with hard and soft pastels.

Oil pastels are different in character from traditional pastels. The pigment and chalk are combined with an oil binder instead of gum, making the sticks stronger and harder. Oil pastels make thick, buttery strokes and their colours are clear and brilliant. Though not as easy to control as the other pastels, they have a robust quality which makes them ideal for direct, spontaneous working. Oil pastels require little or no spray fixative as they do not smudge easily.

COLOURED PENCILS

An increasingly popular drawing medium, coloured pencils offer the same lively linear quality as graphite pencils, but with the added bonus of colour. In use, coloured pencils can be overlaid to create visual blending of colours, but they cannot be mixed like paints. For this reason, they are produced in many different colours, shades and tints.

WATER-SOLUBLE PENCILS

These are similar in appearance to ordinary coloured pencils, but the lead contains a water-sensitive binder. You can apply the colour dry, as you would with an ordinary coloured pencil, and you can also use a soft watercolour brush dipped in water to blend colours together on the paper to create a wash-like effect.

CONTÉ CRAYONS

These are oblong sticks of very high-grade compressed chalk, slightly harder and oilier than pastels. Traditionally used for tonal drawings, conté crayons were in the past limited to black, white, grey and three earth colours – sanguine, sepia and bistre. Recently a wide range of bright and subtle colours has been introduced, available individually or in boxed sets.

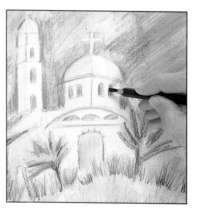

Water-soluble pencils can be used as both a painting and a drawing medium.

You can use the flat side of the crayon for shading and creating broad, flat areas of colour, or you can break off small pieces and use a corner or edge to make crisp outlines. Conté crayons combine well with soft pastels and with charcoal, and are shown to their best advantage when used on tinted paper with a fairly rough texture.

DRAWING INKS

There are two types of drawing ink: water-soluble and waterproof. Both types come in a wide range of colours as well as the traditional black. With water-soluble inks the drawn lines can be dissolved with water and the colours blended. With waterproof inks the lines remain intact and will not dissolve once dry, so that a wash or tint on top of the drawing may be added without spoiling the linework. Water-soluble ink should be used with all pens except dip pens to ensure that they do not clog.

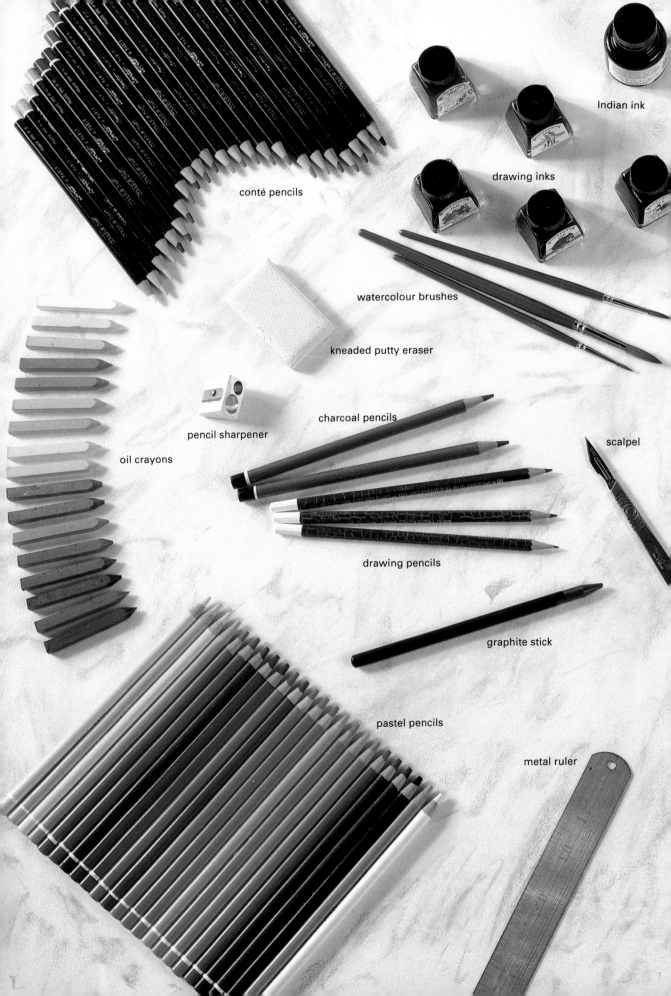

conté pencils

Indian ink

drawing inks

watercolour brushes

kneaded putty eraser

oil crayons

pencil sharpener

charcoal pencils

scalpel

drawing pencils

graphite stick

pastel pencils

metal ruler

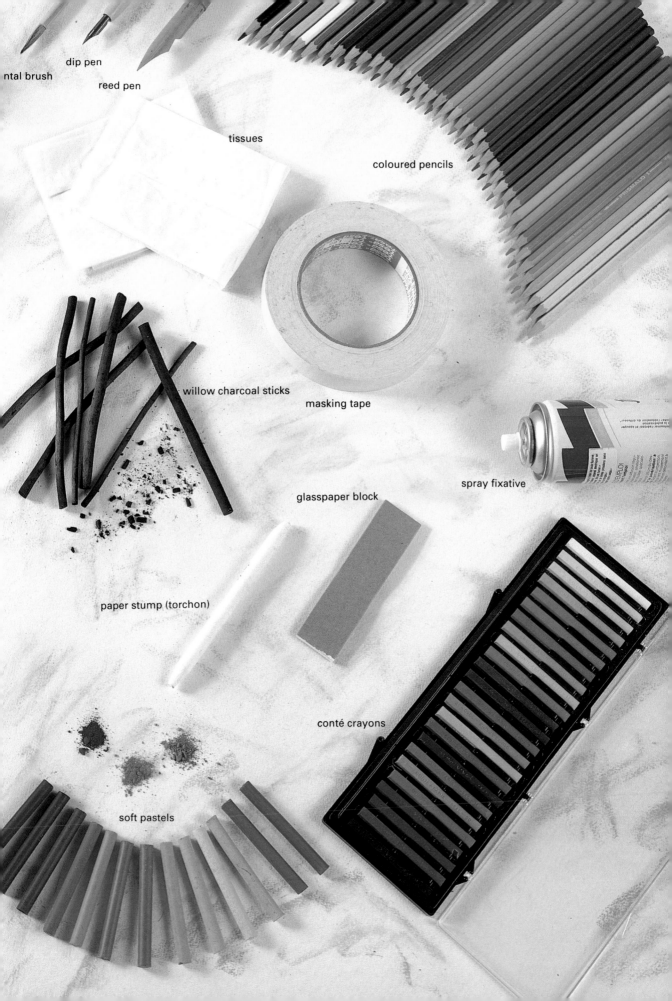

ntal brush

dip pen

reed pen

tissues

coloured pencils

masking tape

willow charcoal sticks

spray fixative

glasspaper block

paper stump (torchon)

conté crayons

soft pastels

PENS AND BRUSHES

Many types of drawing pen are available today. Simple dip pens consist of a holder which can be used with a selection of nibs. They produce flowing lines that can be made to swell and thin. The more traditional reed pens produce soft, slightly irregular strokes, making them ideal for bold line drawings. They are available from art supply stores, but many people prefer to make their own pens from bamboo cane.

Fountain pens with their built-in supply of ink are useful for impromptu sketching because they don't need to be dipped into ink frequently. They are smoother to draw with than dip pens, but the nib range is more limited and most fountain pens need water-soluble ink to prevent them from clogging. Fibre-tipped pens and marker pens are available in a wide range of colours. Technical pens produce a controlled, even line and are more suited to detailed line work.

Watercolour brushes have a pleasing, springy quality that is well suited to brush drawing with ink. Bamboo-handled oriental brushes are inexpensive

A small selection from the wide range of drawing papers available includes: 1 sugar (craft) paper; 2 and 6 cartridge (drawing) paper; 3 flour paper; 4 spiral-bound sketch book; 5 tinted watercolour paper; 7 vellum; and 8 Ingres pastel paper. An art folder (9) is useful for transporting drawings.

and their soft, pointed bristles produce flowing, natural lines.

PAPERS

Drawing paper is available in a wide range of weights, textures and colours, and can be purchased as single sheets, pads, sketchbooks or as boards which provide a firm support.

The texture of the paper – how rough or smooth it is – will affect the way you draw. Machine-made papers are available in different finishes: "hot-pressed" (HP); "Not", meaning not hot-pressed (cold pressed); or "rough". Hot-pressed papers are smooth; Not papers have a medium texture, or "tooth"; and rough papers, as the name suggests, have a coarse texture.

The "weight" of a paper refers to its thickness. Lightweight papers will buckle when wet washes of ink or paint are applied, so choose a good-quality heavy, paper.

Choosing a Paper

The character of the paper can influence a drawing quite dramatically, so it is important to choose carefully. It is worth exploring the effects of a single medium on different papers; they can vary enormously.

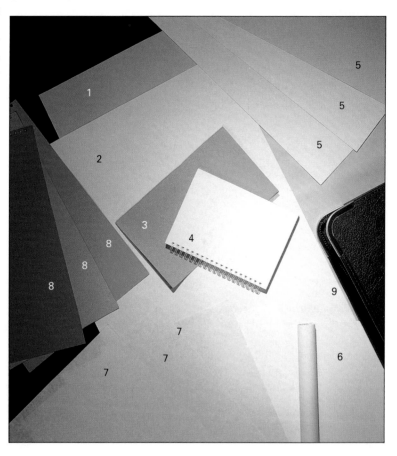

Pencil Almost any type of surface can be used for pencil work. Generally, a smooth paper is most suitable for finely detailed drawing, and rougher surfaces for bold drawing.

Coloured pencil A smooth or medium-textured paper is best for coloured pencils. The water-soluble variety requires a heavy, watercolour-type paper to withstand wetting.

Pastel and charcoal Powdery materials such as pastel and charcoal need a support with enough surface texture to hold the particles of pigment. Smooth or shiny papers are unsuitable because the pastel or charcoal stick slides around and the marks are easily smudged. Waxy materials such as conté, oil pastel and wax crayon also work best on a textured surface. Canson, Ingres (charcoal), Fabriano and the inexpensive sugar (craft) papers are all good for charcoal and chalks.

When working with any of the above materials, choose a tinted paper, against which both lights and darks show up well. Pastel papers come in a range of surfaces: soft velour for blending colours smoothly and evenly; medium grain for general purposes; rough textured for lively, vigorous work; and very fine grade flour paper which can hold dense layers of pastel and produce a strong, brilliant effect.

Pen and ink Bristol board has a very smooth, brilliant white surface and is ideal for pen and ink. It comes in different thicknesses, the lighter weights being more like a sturdy paper than a board. Smooth cartridge (drawing) paper is also suited to pen drawing, but brush and ink works well on a Not (cold-pressed) or rough surface, which breaks up the strokes and adds sparkle and vigour to the drawing.

DRAWING ACCESSORIES

Erasers For erasing, plastic or kneaded putty erasers are best, as the familiar India rubber (pink pearl) tends to smudge and can damage the paper surface. Putty erasers are very malleable; small pieces can be broken off and rolled to a point to reach fine details. A putty eraser can also be pressed onto the paper, and unwanted marks lifted off simply by pulling it away. Use it on soft graphite, charcoal or pastel drawings, both to erase and to create highlights.

Paper stumps Paper stumps, also called torchons, are used for blending or shading charcoal, pastel or soft graphite drawings. Made of tightly rolled paper, they have tapered ends for working on large areas and a sharp point for small, delicate details.

Knives and sharpeners A sharp craft knife or scalpel for sharpening pencils and cutting paper is also needed. Knives are very useful too for scratching lines into an oil pastel drawing to create interesting textures – a technique known as sgraffito (see pages 90-94). A pencil sharpener is convenient, though a knife is prefer-

Drawings executed in soft media such as pastel, charcoal or soft pencil should be sprayed with fixative to prevent smudging.

able as it gives a longer point and is less prone to breaking the lead. Sandpaper blocks, consisting of small, tear-off sheets of sandpaper stapled together, are useful for getting fine points on graphite sticks, pastels, crayons and charcoal sticks.

Drawing board If you draw on sheets of loose paper you will need a firm support. You can buy a commercial drawing board at an art supply store, but it is far cheaper to get a good piece of smooth board from a timber merchant (lumberyard). If the drawing board feels too hard, place a few extra sheets of paper under the top one to make a more yielding surface.

Fixative If you are using pastel, chalk, charcoal or soft graphite pencil, the best way to preserve your drawings is to spray them with fixative. This varnish-like fluid binds the particles of pigment to the surface of the paper so they will not smudge, smear or shake off. Fixative is available in aerosol spray form or mouth-type atomizers.

BASIC TECHNIQUES

MAKING MARKS

The first step in drawing is to discover the potential expressive range of your chosen medium by experimenting with the marks it can make. Start by making random marks on scrap paper – scribbling, hatching and rubbing until the drawing instrument seems to be an extension of your hand.

Pencil

The immediacy and sensitivity of pencils make them the most popular tool for drawing. The character of a pencil line is influenced by the grade of pencil used, the pressure applied, the speed with which the line is drawn, and the type of paper used. Soft pencils are good for rapid sketching and encourage a bold, gestural style of drawing. Hard pencils make fine, incisive lines and are better suited to detailed representational drawing. Tonal effects are achieved by means of hatched and crosshatched lines; by varying the density of the lines, fine gradations in tone from light to dark can be created.

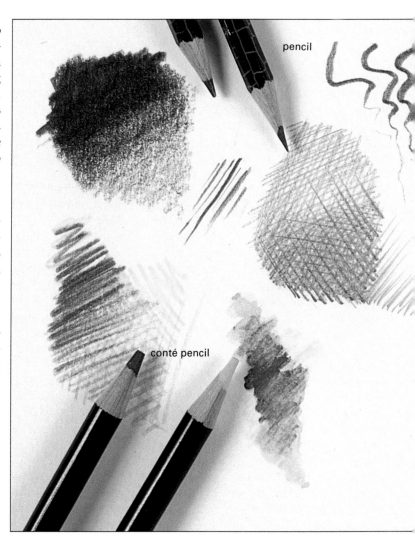

pencil

conté pencil

Charcoal

Charcoal is a uniquely expressive medium with a delightful "feel" to it as it glides across the paper. With only a slight variation in pressure on the stick a wide range of effects is possible, from delicate hatching to strong and vigorous marks. Because charcoal smudges so easily it can also be rubbed and blended for rich tonal effects, and highlights can be picked out with a kneaded putty eraser. Charcoal is messy to handle, and it is advisable to use spray fixative to prevent unwanted smudging.

Pastel and Crayon

Pastels, chalks and crayons are extremely versatile in that they can be both a drawing and a painting medium. By twisting and turning the stick, using the tip and the side, it is possible to obtain both expressive lines and broad "washes" of colour.

Soft pastels and chalks, being powdery, can be blended easily to create a delicate veil of colour, but a more lively effect is gained by combining blended areas with open linear work. The density of colour is controlled by the amount of pressure applied; with strong pressure you can achieve the density of oil paint, and this effect can be contrasted with strokes that pass lightly over the surface.

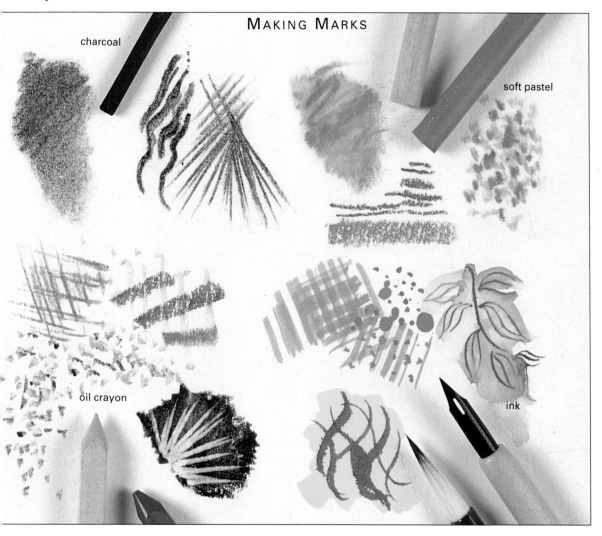

MAKING MARKS

charcoal

soft pastel

oil crayon

ink

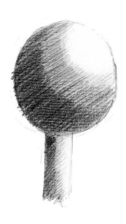

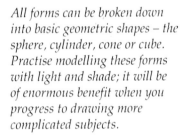

All forms can be broken down into basic geometric shapes – the sphere, cylinder, cone or cube. Practise modelling these forms with light and shade; it will be of enormous benefit when you progress to drawing more complicated subjects.

Ink

Whether it is bold and dynamic or delicate and lacy, ink drawing has a striking impact. Pen and ink is a linear medium and pen marks cannot be varied tonally by altering the pressure on the nib as easily as pencil marks can. Tones must be rendered with lines or marks, overlapping or varying the spacing to create degrees of light and dark. Ink can also be applied with a soft brush to create a completely different range of marks, and washes can be laid down using diluted ink.

FORM AND VOLUME

The way light and shadow fall on objects helps to describe their solid, three-dimensional

form. In drawing and painting, solidity and the illusion of a third dimension is suggested by using tonal values – degrees of light and dark. Natural forms such as clouds and trees often have complex and irregular shapes which make it difficult to represent the subtle areas of light and shadow.

The best approach is to ignore distracting detail and simplify what you see, breaking the subject down into basic areas of light and shade. These simplified areas are called "planes". The lightest planes are those areas that receive direct light; the darkest are those furthest from the light source. In between are the mid-tones – varying degrees of light and dark. Once you have established the basic form and structure of your subject by simplifying it into planes of light and shade, you will find it easier to develop detail and refine the drawing by breaking up these simplified major planes into smaller, more complex and subtle ones.

PROPORTIONS OF THE FIGURE

Most artists gauge the proportions of the figure by taking the head as their unit of measurement. Generally speaking, the head of a standing adult fits into the total height of the figure about seven times. This is a useful guide, but remember that no two people are built exactly alike or carry themselves in the same way, and there is no substitute for sensitive observation of the actual subject.

A common mistake in drawing figures is to make the arms too short and the hands too small. When the arms are relaxed, the tips of the fingers hang a considerable way down the thighs, and the hands measure almost one head unit.

Seated Figures

When drawing a seated figure, use the proportions of the chair as a guide. Within this frame, mark off the position of various points of the body – shoulders, hips, thighs, knees – in relation to the back, seat and legs of the chair. Foreshortening of the legs, particularly if they are crossed, can be difficult to represent convincingly. The tendency is to draw what we know, not what we see; it is vital to look repeatedly at your model, to check that angles and proportions are correct, and, most of all, to trust what your eyes tell you.

A useful tip is to regard the figure as a two-dimensional shape and draw its outline as accurately as you can.

GALLERY

Avast range of drawing materials, supports and equipment is now available to the artist, and the opportunities for personal expression are without limit. The drawings shown on the following pages demonstrate a broad cross-section of techniques and media, and reveal how each of these can be used in different ways and for a variety of subjects.

Some of the artists featured have employed traditional methods that go back to the Renaissance, such as line and wash, hatching and crosshatching. Other artists have used experimental techniques and materials – drawing with inks and bleach, for example – to create particular effects. Their drawings should serve to inspire you to experiment with media and techniques and open up new horizons.

African Village

Annie Wood

51 x 36cm (20 x 14in)

This drawing is a fine example of the intricate textural and colour effects that can be achieved using sgraffito. In this technique, the broad colour areas of the design are first blocked in with wax crayons; the entire area is then covered with a layer of black wax crayon and this is scratched into with a sharp instrument, revealing the colours beneath.

23

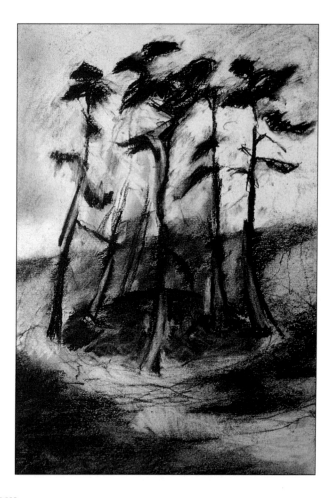

Foxhall Heath

Sheila Bryan

28 x 18cm (11 x 7in)

This ancient Roman burial ground has fascinated the artist since childhood. Working from imagination and memory, she has exploited the dense tonal qualities of black conté crayon to convey both the starkness of the scene and its haunting atmosphere. The sky and landscape were laid in with the side of the crayon and the lighter tones lifted out using tissue paper and an eraser, while the dramatic shapes of the Scots pines were drawn directly with the point of the crayon.

Mr Bill

Kay Gallwey

41 x 46cm (16 x 18in)

Pastel, charcoal and watercolour are combined in this lively and sympathetic study of a cat. The support is a sheet of beige Ingres (charcoal) paper, its colour providing a useful mid-tone which shows through the drawn marks, holding them together. The cat's ginger fur was washed in with watercolour paint, applied with a rag. Over this, scribbled strokes of charcoal and white pastel were used to outline the form and express the texture of the soft fur.

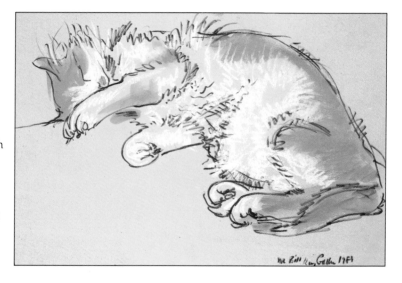

Life Study

Rosemary Young

40 x 44cm (15½ x 17½in)

As a sculptress, Young is naturally interested in the play of light and shade on forms. Here the contours of the figure were modelled with vigorous hatched strokes using an 8B pencil. Then a hard eraser was used to smudge some of the tones, and a soft putty eraser to lift out the highlights, almost as if carving out the forms. It is hard to believe that such a finely wrought drawing was executed while standing well back from an easel, the pencil tied to the end of a stick!

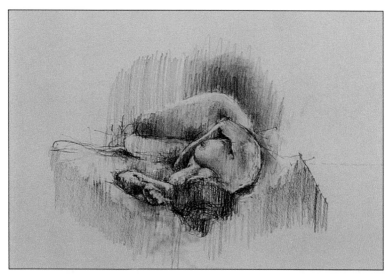

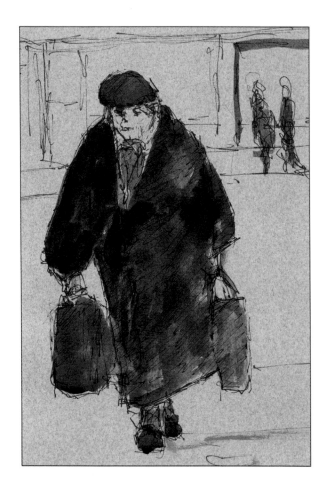

The Shopper

John Denahy

19 x 13cm (7½ x 5in)

This line-and-wash drawing is a touching and humourous study of an old woman returning from the market weighed down with her shopping. Denahy first sketched in the form of the figure with rapid, scribbled lines using a technical pen. Then he used sepia ink – less harsh than dense black – and a brush to wash in the dark tones that convey the bulk of the figure. The sketchily drawn background lends a sense of scale to the drawing and acts as a counterpoint to the main figure.

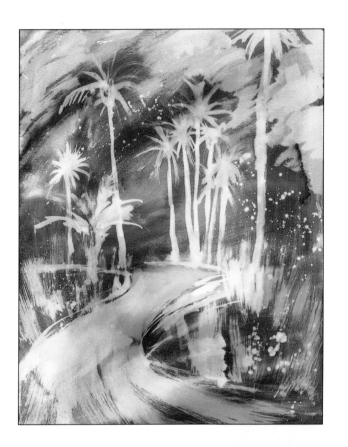

Night in the Rainforest

Annie Wood

71 x 51cm (28 x 20in)

This is an example of a bleach drawing. The technique involves covering the paper with writing ink and then drawing into it with a brush or drawing implement dipped into diluted household bleach. The bleached areas turn a pale golden brown, so the finished drawing has the mellow beauty of an old sepia-tinted photograph. This image was drawn with an old, splayed brush, and in places the bleach is spattered onto the paper by flicking the brush.

Corsican Landscape

Joan Elliott Bates

51 x 41cm (20 x 16in)

A strong sense of space and of the massive bulk of the mountains is expressed in this mixed-media drawing. Working on a watercolour block, the artist drew the linear framework with compressed charcoal (which does not smudge and requires no fixing) and then washed in the tones with watercolour. In places she worked into the washes with water-soluble crayons to add definition and help knit the colour in with the black lines.

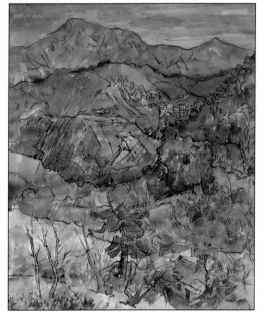

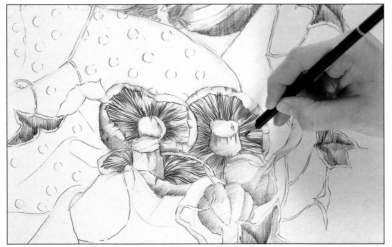

7

Draw the dark gills of the mushrooms with strong lines using a 2H pencil.

8

Indicate the form of the foreground drapery with vertical hatched strokes, using a B pencil for the lighter tones and a 2B for the darker ones. Vary the density of the lines and leave areas of paper untouched for the highlights and the white polka dots.

Fill in the dark backcloth with a 2B pencil. Lay down closely spaced parallel lines, working first in one direction and then going over them in another, until the required density of tone is achieved.

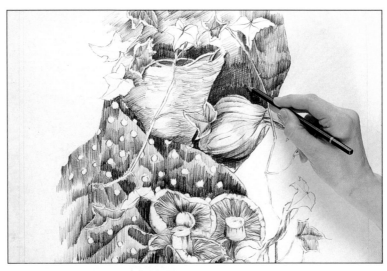

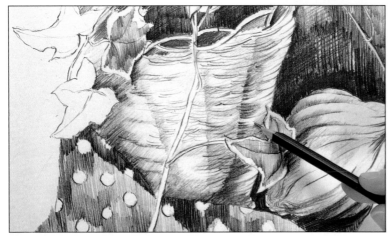

9

Finally, add further texture to the wicker basket with curved strokes using a 2B pencil.

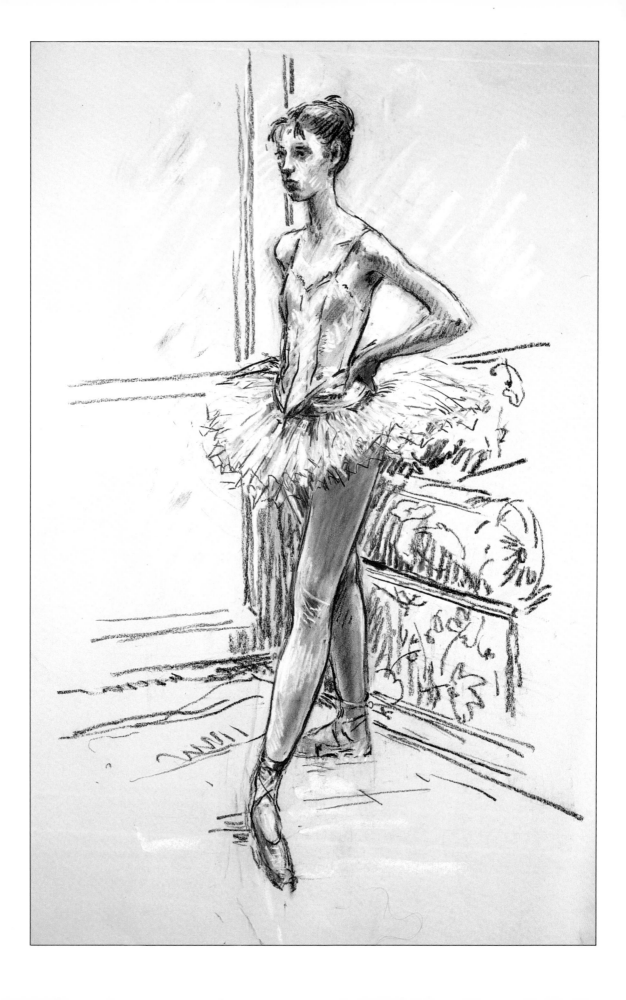

BLENDING WITH CHARCOAL AND CHALK

Charcoal and chalk are so immediate and responsive in use, they are almost an extension of the artist's fingers. Used together they give a full tonal range, from pale silver-grey to rich velvety black, and also a sensitive line. By varying the pressure on the charcoal stick it is possible to produce a wide range of effects, combining strong and vigorous linear work with delicate smudges.

In this lovely drawing of a dancer, the gesture of the pose is conveyed through the varying quality of the charcoal lines. A combination of smoothly blended tones and fine hatching describes the contours of the figure. The "lost and found" quality of the drawing retains a pleasing spontaneity.

~

Kay Gallwey
Ballet Dancer
79 x 53cm (31 x 21in)

~

BLENDING TECHNIQUE

One of the attractions of powdery media such as pastel, charcoal, chalks and crayons is that they are easily blended to create soft, velvety tones and subtle gradations from dark to light. The blending technique has many uses – in softening fine lines and details, suggesting smooth textures, modelling form with degrees of light and shade, lightening tones, and tying shapes together.

To create an area of blended tone, either apply lightly scribbled strokes with the point of the stick, or use the side of the stick to make a broad mark. Do not press too hard on the stick – if the mark is too ingrained it will be difficult to blend. Lightly rub the surface with a fingertip to blend and create an even tone. Repeat the process if a darker tone is required.

Colours or tones can be fused together softly by blending with a fingertip, or with rags, tissue, brushes or paper stumps (torchons). Depending on the subject, you can use purely blended tones or mix blended and linear tone techniques to add variety and texture. Another approach is to create an area of soft blending and then overlay it with linear strokes. Here, the blended tones act something like an underpainting, adding extra depth and subtlety to the drawing, while the strokes have the effect of tying the drawing together.

As a general rule, the smoother the surface of the paper, the easier it is to blend tones. On the other hand, a textured paper can actually enhance the blending effect, creating a more random, broken texture. The colour of the paper also plays an important part in the drawing. A light grey paper is a good choice for drawings in charcoal and chalk, making it easier to judge the light and dark tones against the mid-tone of the paper.

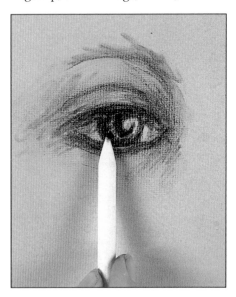

A paper stump (torchon) is useful for blending and darkening small areas and intricate shapes.

BALLET DANCER

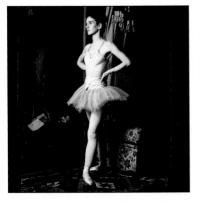

Left: The model is posed beside a window so that the light creates strong patterns of light and shade on the body. Because she is a dancer, she instinctively strikes a pose that is at once graceful and relaxed.

Materials and Equipment
• SHEET OF PALE GREY INGRES (CHARCOAL) PAPER • STICK OF CHARCOAL, MEDIUM THICKNESS • STICK OF WHITE CHALK OR CONTÉ CRAYON • SPRAY FIXATIVE

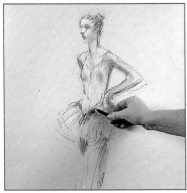

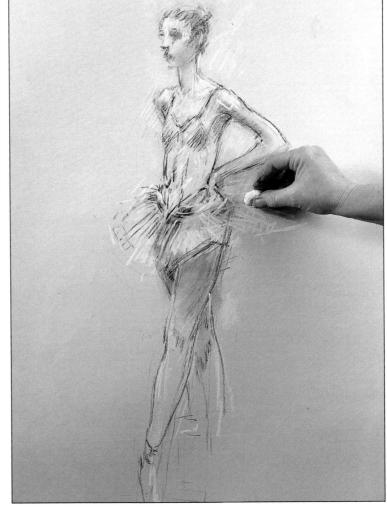

1
Use a craft knife to sharpen the charcoal stick to a point. Sketch out the figure with light, feathery lines, checking that the proportions are correct (see pages 18–19).

2
When you are satisfied with the proportions and the gesture of the figure, begin strengthening the charcoal lines, still working lightly. Block in the shadows on the thighs with light strokes smudged and softened with the finger. Suggest the tulle skirt of the dancer's tutu with light strokes of white chalk, and pick out the highlights on the legs.

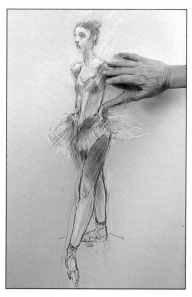

3

Define the forms of the arms and upper torso with more softly blended charcoal strokes. Strengthen the contours of the legs to convey the feeling of the model's weight resting on them. Lightly draw the model's ballet shoes.

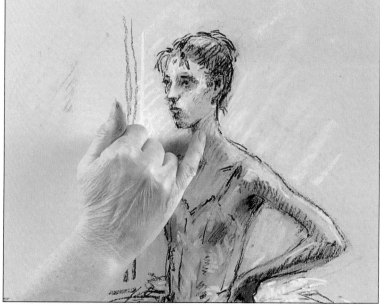

4

Sharpen the charcoal stick to a fine point and draw the model's hair and facial features. Indicate the shadow on the throat with charcoal, and the highlight running along the shoulder and the back of the neck with white chalk or conté crayon, blending the two tones together with feather-light strokes of a fingertip.

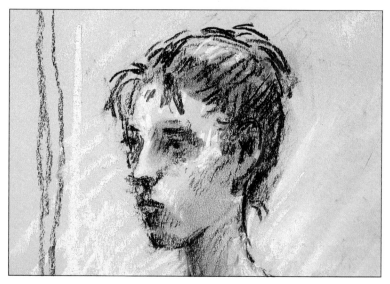

Left: The sheer poetry of the drawn line is demonstrated in this close-up detail of the head. The combination of softly blended tones overlaid with broken lines of charcoal and chalk suggests without overstating, and the marks themselves are beautiful in their own right.

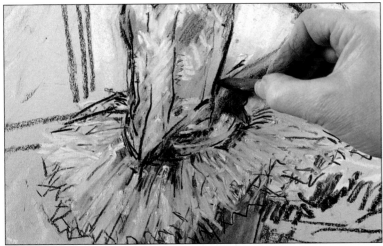

5

Continue to bring the drawing "into focus" by adding more linear details with both the charcoal and the chalk. Refine the texture of the tulle skirt of the tutu with semi-blended strokes of chalk and charcoal.

6

Complete the modelling of the legs with blended strokes of charcoal, overlaid with strokes of white to suggest the sheen of the dancer's tights. Finish off the ballet pumps, keeping the outlines soft and broken so that the feet appear to rest on the floor; tight outlines make the feet appear "cut out" from the background. Finally, sketch in just enough background detail to place the figure in context, without overwhelming the main subject. Spray the drawing with fixative to prevent accidental smudging.

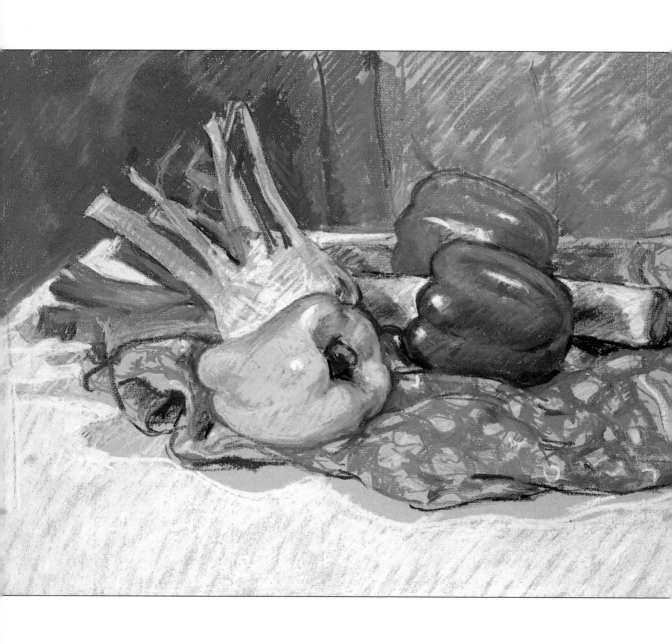

Technique

3

BUILDING UP

The vibrant colours and thick, buttery texture of oil pastels have been exploited to the full in this colourful group of vegetables arranged on a kitchen table.

Working with oil pastels is an exciting challenge. Because of their waxy texture, only a minimal amount of blending is possible so colour and form have to be built up in layers of hatched and crosshatched strokes to obtain solid areas of colour. To introduce textural variety and to prevent the drawing from appearing dense and overworked, the artist has left some areas in a fairly loose linear state, in contrast with the more solid areas of colour used, for example, on the peppers. Allowing the paper to show through helps to breathe air into the drawing, and in addition the cool, neutral tone of the paper becomes integrated into the composition, enhancing the bright colours of the subject.

~

Elizabeth Moore
Still Life with Peppers
33 x 43cm (13 x 17in)

~

THE BUILDING-UP TECHNIQUE

Most drawings – apart from quick sketches – have to be built up in stages, working from "the general to the particular". This applies particularly to pastels, oil pastels, charcoal and chalks, where the nature of the medium necessitates areas of colour being built up in several layers, one on top of the other. This is because powdery or waxy pigment tends to clog the surface "tooth" of the paper if applied too heavily in the early stages of a drawing, so that the surface becomes slippery and difficult to work on. To avoid this, it is best to start by working lightly and sketchily, feeling out the shapes and forms, and to work up gradually to thicker layers of colour. In the case of soft pastel and charcoal, it is helpful to fix the drawing at various stages with spray fixative so that further layers of colour can be built up without muddying those underneath (in the case of oil pastels, however, fixing is generally not necessary).

After sketching the outlines of the subject, block in the main colour areas lightly, either by scribbling with the

point of the pastel stick or using it on its side to apply broad strokes. Continue adding further layers of colour, building up the density of pigment and intensity of colour required. To prevent the drawing from becoming too dense and overworked, it is advisable to allow the tone of the paper to break through the strokes in some areas.

Oil pastels are a bold, exciting medium, with an immediacy that makes them ideal for the inexperienced artist. Lack of confidence often makes beginners draw too tightly and meticulously and overwork their drawings. Working with a robust medium like oil pastels encourages a freer approach that will be of enormous benefit in developing greater confidence.

In fact, oil pastels are not suited to small-scale detailed work; the sticks are too chunky and fine blending is not possible. Far better to exploit the tactile qualities of the medium and work on a large scale using vigorous, textural strokes and building up a rich patina of waxy colour.

Break off a small piece of the pastel stick and use the side to build up thick, solid layers of colour.

STILL LIFE WITH PEPPERS

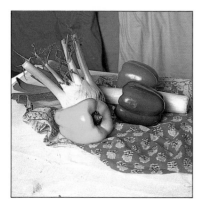

Left: A group of vegetables makes an excellent subject for a still-life study. This combination of a leek, a bulb of fennel and three peppers was chosen for the exciting contrasts of shape, colour and texture it contains.

Materials and Equipment
• SHEET OF NEUTRAL GREY CANSON PASTEL PAPER • OIL PASTELS: CADMIUM RED, OLIVE GREEN, WINSOR BLUE, COBALT BLUE, ALIZARIN CRIMSON, WHITE, LEAF GREEN, RAW UMBER, LEMON YELLOW, CADMIUM YELLOW, YELLOW OCHRE AND CERULEAN

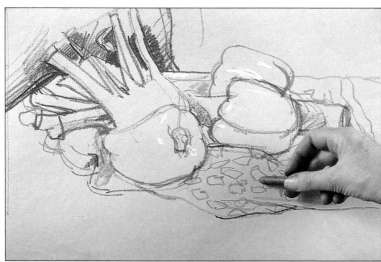

1

With the point of the pastel stick, draw in the outlines of the vegetables using cadmium red for the red pepper and olive green for the remaining vegetables. Sketch the folds and pattern of the red cloth with cadmium red and suggest the dark blue background cloth with Winsor blue. Draw the lines lightly, feeling around the objects, correcting a shape by re-drawing it. Any unwanted lines will be obliterated later by thick strokes of oil pastel.

2

Sketch in the light blue background cloth with loose strokes of cobalt blue. Begin to build up the colour of each vegetable with fairly dense strokes. For the red pepper use cadmium red, darkening the shadow areas with alizarin crimson. Merge the two tones of red together by overlapping the strokes and smudging them with a fingertip. Apply thick strokes of white for the shiny highlights.

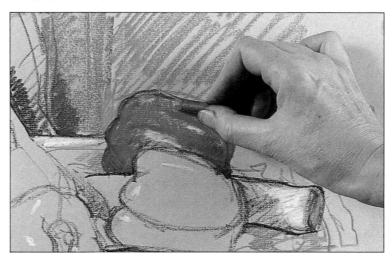

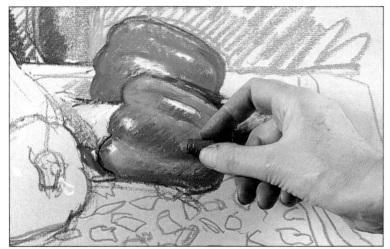

3

Build up the green pepper using leaf green for the light parts and olive green for the darks. Add white for the highlights, and again smudge some of the tones together with a fingertip to suggest the bulbous form of the pepper.

4

Use semi-blended strokes of white, leaf green and raw umber for the stalk of the leek. Begin to build up the form of the yellow pepper with dense strokes of lemon yellow, allowing areas of the paper to show through between the patches of colour.

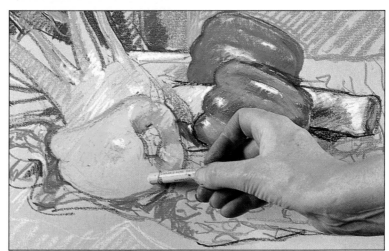

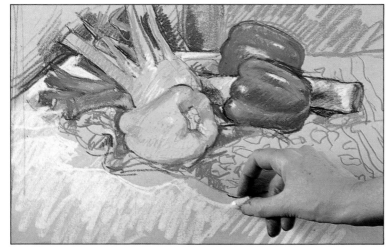

5

Complete the yellow pepper, building up layers of hatched lines and smudged colour. Use lemon yellow for the light tones, overlaid with cadmium yellow for the mid-tones and yellow ochre for the deepest shadows. Begin blocking in the foliage on the leek and fennel with mixtures of olive green and leaf green. With a white crayon, roughly hatch in the white table cloth, leaving patches of untouched paper to convey the shadow cast by the red patterned cloth.

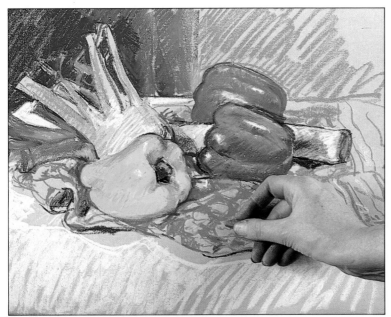

6

Draw the stalk of the yellow pepper with olive green and raw umber. Continue to relate the still life to its background by deepening the tones on the dark blue backcloth with further strokes of Winsor blue and cobalt blue. Fill in the pattern on the red cloth with cadmium red, alizarin crimson and cadmium yellow.

7

Continue to refine the drawing, observing the play of light on the forms, altering the tones and intensities of the colours where necessary. Finish off the light blue backcloth with strokes of cerulean blue partially blended with white.

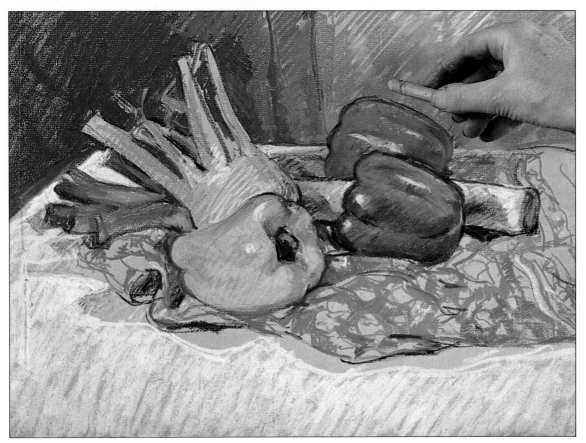

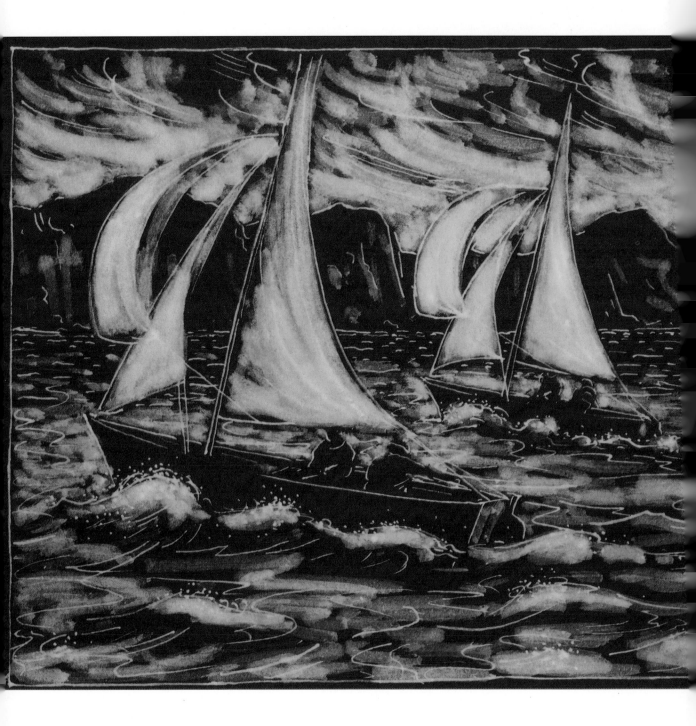

Technique
4

THE BLEACH-OUT TECHNIQUE

In the unusual and exciting technique known as bleach out the image is "drawn" onto a background of black ink using ordinary household bleach. This produces an effect closely resembling a sepia print, and bleach-out drawings are full of mood and atmosphere.

The bleach-out technique is suitable for almost any subject, but an image with strong tonal and textural contrasts gives the most effective results. In this drawing of two racing yachts, the strong light-and-dark contrasts and the sweeping shapes of the sails, waves and clouds convey the exhilarating nature of the scene.

~

Ted Gould
Yachts
20 x 23cm (8 x 9in)

~

USING THE BLEACH-OUT TECHNIQUE

Bleach out is a "negative" method of drawing in that a light image is drawn onto a dark background, as opposed to the more conventional "positive" drawing methods in which dark lines are drawn on a light background. It is a simple technique, requiring the minimum of materials, yet it produces striking effects unobtainable with any other medium.

All you need is a sheet of fairly heavy cartridge (drawing) paper or Bristol board, some black fountain pen ink and almost any type of improvised tool with which to draw the image in bleach on the ink. Cotton buds (swabs) are excellent for making a range of dabs and strokes, and dip pens for lines and fine details. Sable brushes should not, however, be used as the bleach would perish or dissolve the hairs.

Start by applying a coat of black fountain pen ink over the entire picture area (two coats provide greater density and contrast). It is important to use fountain pen ink – the technique will not work successfully with water-soluble ink, or with waterproof Indian ink. When the ink is completely dry, use a white conté crayon to sketch the main outlines of the image.

Pour a little household bleach into a small glass jar, then dip your chosen drawing implement into it and lightly "draw" the areas that are to be the lightest tones in the image. You may find it useful to lay a sheet of paper beneath the area you are working on, to prevent smudging the conté drawing and also to catch any accidental drips of bleach.

Where the bleach is applied, it dissolves the ink, but the light areas do not appear white as you might expect; they are a very attractive warm sepia colour. By applying the bleach lightly at first, then more heavily, a range of subtle tones can be built up. If you do unintentionally obliterate an area with bleach, you can re-touch it with ink.

Before embarking on your first bleach-out drawing, spend some time considering the end result. Make a pencil sketch, indicating the placing of tones and masses. This will help you to decide where the darks, mid-tones and lights are to be.

Note: When using bleach, take care not to get any on your skin or in your eyes, and work in a well-ventilated room.

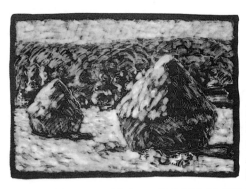

Drawings of great tonal and textural beauty can be achieved with the bleach-out technique. This drawing is based on Monet's painting, Grain Stacks, End of Summer, Morning Effect, *(1891).*

YACHTS

Right: A photograph from an old sailing book provided the reference for this drawing.

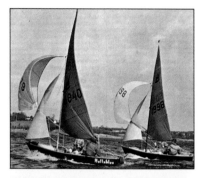

Materials and Equipment

• SHEET OF CARTRIDGE (DRAWING) PAPER OR BRISTOL BOARD • LARGE FLAT WATERCOLOUR BRUSH • BLACK FOUNTAIN PEN INK • WHITE CONTÉ CRAYON • HOUSEHOLD BLEACH • SMALL GLASS JAR • COTTON BUDS (SWABS) • DIP PEN WITH FINE NIB

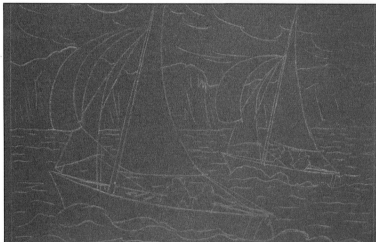

1

With a large flat watercolour brush, lay an even wash of black fountain pen ink all over the picture area. Leave to dry. Then apply a second coat and leave to dry thoroughly. Applying light pressure, draw the outlines of the image directly onto the black ink with white conté crayon. If you make a mistake, the lines can be erased by rubbing with a fingertip or a soft eraser.

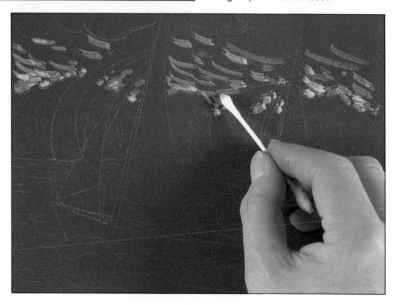

2

Pour a little household bleach into a small glass jar. Dip a cotton bud (swab) into it and begin "drawing" the clouds with small, curved strokes. Be careful not to use too much bleach at this stage.

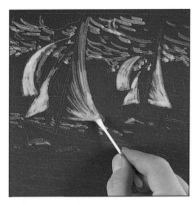

3

Still using bleach applied with a cotton bud, begin blocking in the sails of the two yachts. Apply the bleach gradually with light strokes to build nuances of light and shade.

4

Now indicate the waves with small, undulating strokes. Use a fresh cotton bud if you find the first one is beginning to disintegrate.

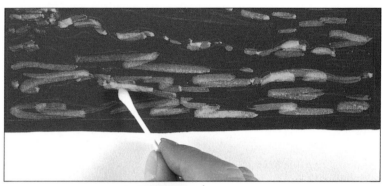

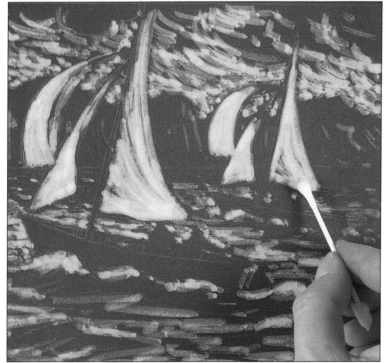

5

Work into the drawing to strengthen the shapes and lighten the tones of the clouds and the sails. Use bolder strokes now, but develop the whole image gradually rather than completing one area and then moving on to the next; this way, there is less danger of any one element "jumping out" because you have applied too much bleach.

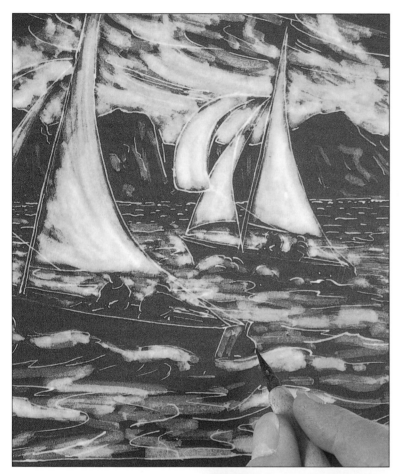

6

Dip the pen nib into the bleach and begin to strengthen the image with linear details. Suggest the craggy outlines of the cliffs in the background, then add linear detail to the yachts and the figures. Then add some sweeping, curving strokes to the sky and water to accentuate the movement of the clouds and waves. These lines provide an effective contrast with the broadly tonal areas.

7

Finally, use the point of the pen nib dipped in bleach to add tiny stippled dots around the waves lapping along the hulls of the yachts. This suggests flecks of foam and enhances the impression of movement.

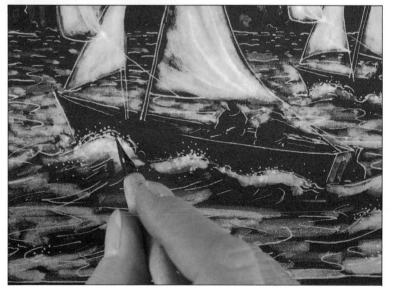

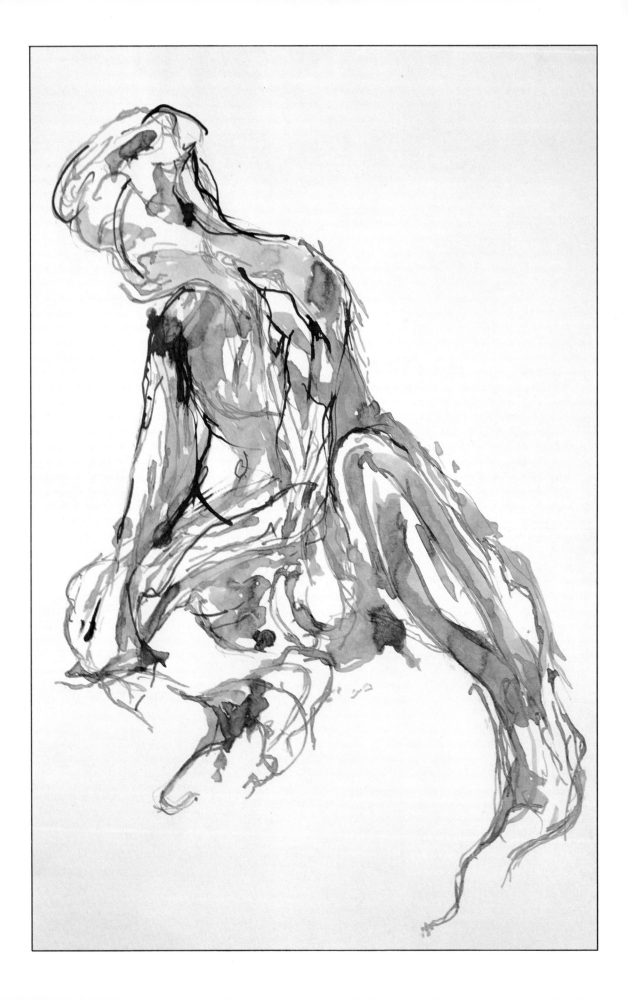

Technique
5

LINE AND WASH

Leonardo da Vinci wrote of drawing as the equivalent of a rough draft of a poem, all the more fertile for being incomplete. Certainly an image which suggests, rather than overstates, lives on in the memory for the simple reason that the viewer actively participates in it, supplying the "missing" elements from his or her own imagination.

In this vigorous line-and-wash study of a male nude, the artist has combined lively brushwork and fluid ink washes with crisp linear marks drawn with a reed pen. Line-and-wash drawings are highly expressive, suggesting more than is actually revealed. The secret is to work rapidly and intuitively, allowing the washes to flow over the "boundaries" of the drawn lines and not be constricted by them.

~

Hil Scott
Male Nude
51 x 38cm (20 x 15in)

~

USING LINE AND WASH

Drawing with pen, brush and ink is an exciting fusion of drawing and painting. The combination of crisp, finely drawn lines and fluid washes has great visual appeal, capturing the essence of the subject with economy and restraint.

The traditional method is to start with a pen drawing, leave it to dry and then lay in light, fluid washes of ink or watercolour on top. Alternatively, washes can be applied first to establish the main tones and the ink lines drawn on top when the washes have dried. The most successful method, however, is to develop both line and tone together so that they emerge as an organic whole.

It is worth experimenting with a range of pens and brushes to discover which ones are best suited to your style of drawing. Dip pens, quill pens and reed pens produce very expressive lines which swell and taper according to the amount of pressure applied to the pen. In contrast, modern technical pens produce thin, spidery lines of even thickness which are suited to a more controlled, graphic style of drawing.

Watercolour brushes can be used both for drawing lines and for laying washes. Avoid using small brushes – large brushes discourage tight, hesitant lines. Bamboo-handled oriental brushes can be bought in most art supply stores. They are very soft and flexible and their long bristles hold a lot of ink and produce expressive, flowing strokes.

It is important to choose the right type of ink for drawing the lines. If you want to overlay washes without dissolving the drawn lines, choose Indian ink, which is waterproof. If you want greater flexibility to be able to dissolve and blend some of the lines, choose a soluble ink such as Chinese (drawing) ink, which is also more delicate than Indian ink.

MALE NUDE

1

In a mixing palette or four small jars, mix four tones of black Chinese (drawing) ink, ranging from extremely diluted to full strength.

Working directly on the paper, suggest the overall pose of the model with gestural lines using the reed pen and the medium-light tone of ink. Work quickly and use a very light touch, referring constantly to the model. Load the oriental brush with the lightest tone of ink and begin suggesting the shadowed parts of the body.

2

Build up on the original framework of the drawing by using the brush and pen together to reinforce the lines and tones using the medium-light tone of ink. Still referring constantly back and forth to the model, concentrate on the major shadows, leaving areas of untouched paper to serve for the highlights.

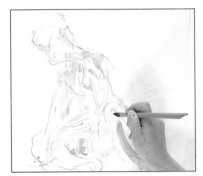

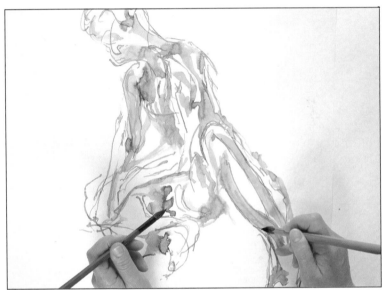

3

Continuing to work very fast, strengthen the darker shadows on the body with the medium-dark tone of ink, again bringing the lines and tones along at the same time. Here you can see the artist, who is ambidextrous, working with the brush in one hand and the pen in the other.

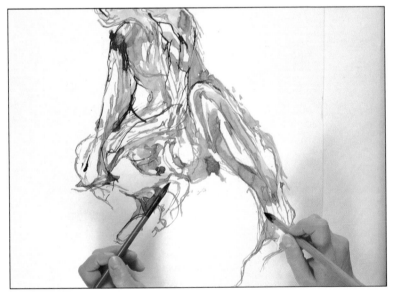

4

Add further washes of medium-dark tone with the brush to enhance the muscular forms of the body further. Dip the pen in the darkest tone of ink and reinforce the gesture and feel of the pose with further lines. Here, for example, dark lines emphasize the tension of the muscles of the shoulders and the back of the neck, and the weight of the arms pressing down on the knees.

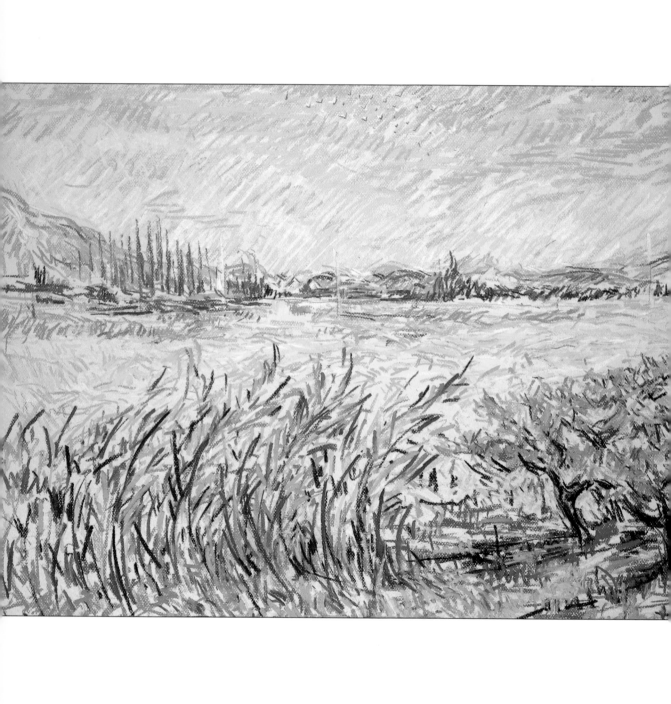

Technique

6

BROKEN COLOUR

In 1888 Vincent van Gogh settled in Arles in southern France, where he drew and painted many landscapes. Since then generations of artists have followed in his footsteps, inspired by the clear light and vibrant colours to be found in this particular region.

In this pastel drawing, the artist's use of pure, unmixed hues and exuberant line work is vividly descriptive of the Provençal countryside under the fierce southern sun. The artist has used a pale, cream-coloured paper, its luminosity playing a crucial role in creating the illusion of intense light. The warm, creamy ground and the cool blues in the sky, for example, enhance each other optically, to give an ethereal, airy quality which aptly evokes the subject.

~

Kay Gallwey
Provençal Landscape
53 x 74cm (21 x 29in)

~

USING BROKEN COLOUR

The term "broken colour" refers to a method of building up areas of tone or colour with small strokes and dabs of pure colour which are not joined, but leave some of the toned paper showing through. When seen from a normal viewing distance, these strokes appear to merge into one mass of colour, but the effect is different from that created by a solid area of smoothly blended colour. What happens is that the incomplete fusion of the strokes produces a flickering optical effect on the eye; the colours scintillate and appear more luminous than a flat area of colour.

This technique is usually associated with the French Impressionist painters, who were the first to exploit its full potential. The Impressionists were fascinated by the effects of light and found that using small, separate strokes of colour was an ideal way to capture the shimmering quality of the bright sunlight of southern France.

Pastels are particularly suited to the broken colour technique because of their pure, vibrant hues and ease of manipulation. However, it is advisable to keep to a fairly limited palette of colours so as to achieve an overall harmony rather than a discordant hotch-potch of colours. In addition, the colours must be close in tone, otherwise the shimmering effect of light is lost.

In the project drawing, for example, most of the colours are light and bright, and even the darkest areas are relatively light in tone. The colour of the paper also contributes to the finished effect, appearing between the broken strokes of pastel and providing a harmonizing element.

Pointillism is another broken colour technique, often used in pastel and coloured pencil drawings. Separate colours are applied as small, closely spaced dots which blend optically and create a sparkling web of colour.

PROVENÇAL LANDSCAPE

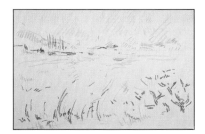

1

It is best to avoid drawing a pencil outline of the composition as this could have an inhibiting effect. Simply plot the main elements with a few sketchy marks using the appropriate colours for each area of the landscape.

2

Begin building up the tones and colours with separate strokes. Work all over the picture with light strokes so that you can build up further layers later without clogging the surface of the paper.

Indicate the sky with loosely hatched strokes of pale blue, the background hills with cool blues and greens and the rice fields with reds and oranges. Use stronger, darker colours in the foreground: blues, pinks and greens for the foreground weeds, and even darker greens and blues for the olive bushes on the right of the picture.

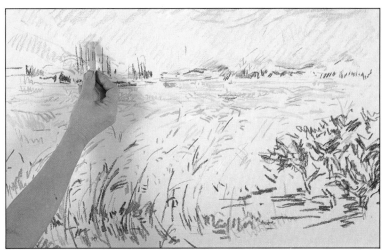

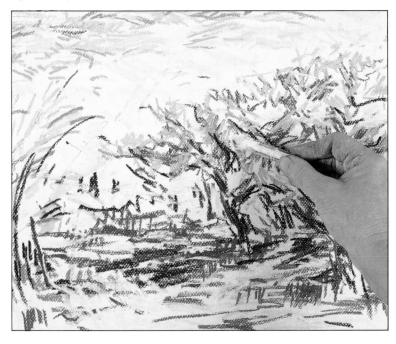

3

Continue laying down strokes of colour, blending them slightly in places but leaving most of them separate. Develop the olive bushes, using dark browns and blues for the trunks and branches. Suggest the foliage with small, scribbled strokes of dark, medium and light green. For the shadows cast by the bushes, use broken, horizontal strokes of dark blues intermixed with pale yellow to indicate reflected light.

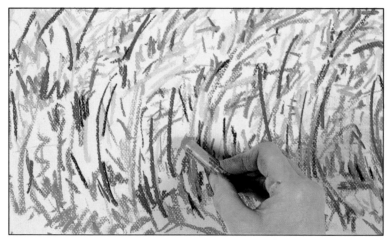

4

Develop the foreground weeds with curving, sinuous strokes of green, blue, pink and purple, still leaving plenty of the paper's colour showing through. Here you can see how the pastel marks are broken up by the paper's texture, adding to the overall sense of movement.

5

Returning to the sky area, build up a web of loosely hatched strokes, again letting the cool tone of the paper show through. To suggest the shimmering light of the sky, use overlaid strokes of two blues that are similarly pale in tone; here the artist is using phthalocyanine blue, which is cool, and ultramarine, which is warm.

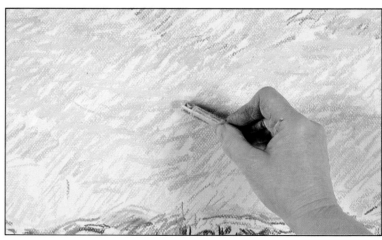

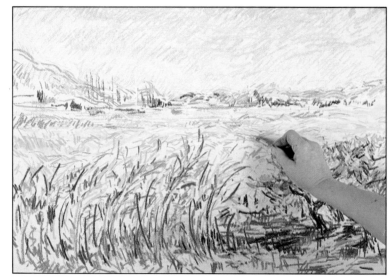

6

Continue working all over the picture with separate strokes of colour that curve to follow the forms. Here the rice fields in the middle distance are being developed with strokes of reds, yellows and oranges. Indicate the tractor in the distance with a tiny stroke of bright red.

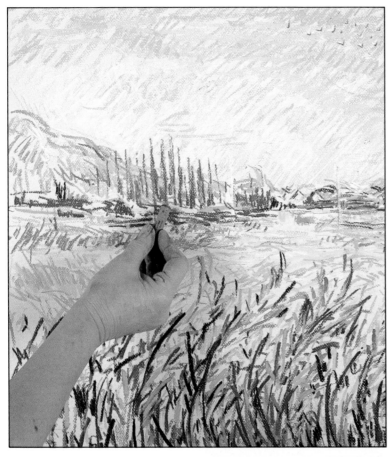

7

Work on the hills and trees in the distance with cool blues and greens. Cool colours tend to recede, whereas warm colours come forward, so by using cool colours in the background and warm colours in the foreground, it is possible to create a sense of distance in the landscape. This principle is known as atmospheric perspective.

8

Finally, add a few strokes of dark blue-grey in the foreground weeds to give them definition and bring them forward in the picture plane. Because pastel is a powdery medium, the completed drawing should be sprayed with fixative.

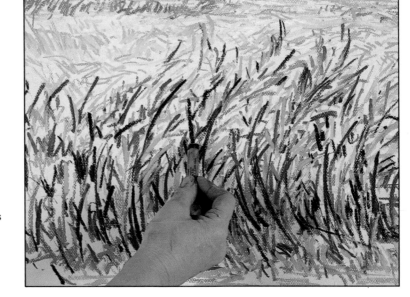

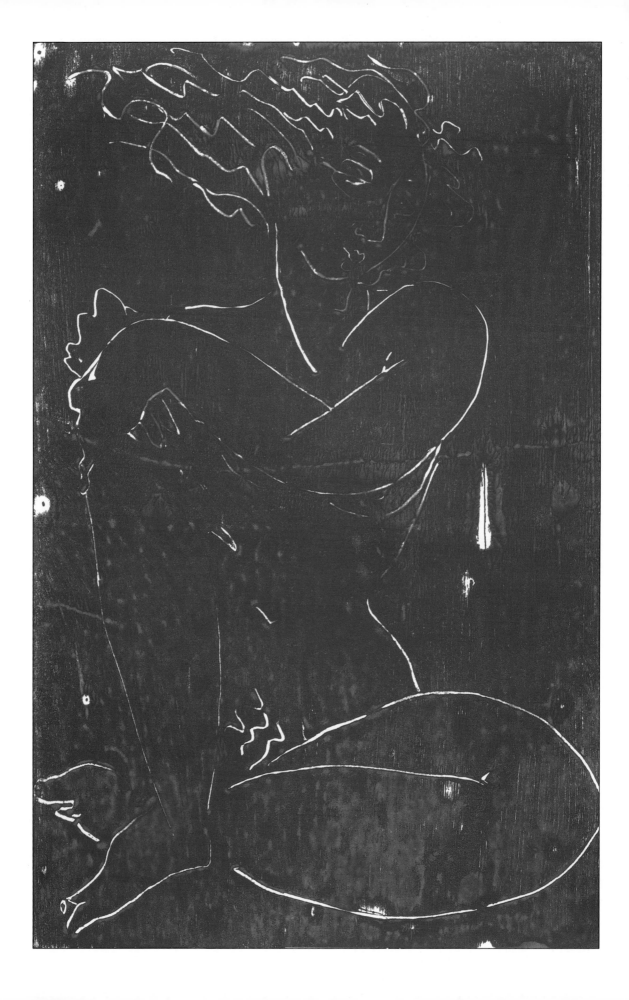

MAKING A MONOTYPE

Monotyping is a fascinating technique which crosses the boundaries between drawing, painting and print-making. It was widely used by the Impressionist painter Edgar Degas as a basis for his pastel paintings. Monotyping is very effective when used as a direct drawing technique; because it is so immediate, it encourages you to lose your inhibitions and draw with a loose, fluid action.

This figure study recalls the drawings of Henri Matisse with its decorative, elegant lines. The artist drew into the paint with a fingernail, making long, sweeping lines that follow each subtle change in the contour of the figure.

~

Kay Gallwey
Female Figure
58 x 41cm (23 x 16in)

~

MONOTYPE TECHNIQUES

Whereas other printing methods can produce a "run" of several identical prints, a monotype is a one-off print, so in fact it is more of a drawing than a printing technique. You can create a single monotype quickly and simply, using the minimum of equipment.

There are three basic methods of monotyping. For the first you need a smooth, non-absorbent surface such as a thick piece of glass or a metal plate, at least as large as the intended print. Draw directly onto this surface using oil paint or printing ink (thicker and more like a paste than drawing ink). Then place a sheet of paper on top of the drawing and press with a hand roller, the palm of your hand or a rag dampened with turpentine. Remove the paper carefully to reveal a reverse impression of the drawing on the chosen surface.

The second method is similar to the first, except that the chosen surface is completely covered with a smooth layer of ink or paint and drawn into to create a "negative" image. Any tool that comes to hand can be used for this – a brush, a clean rag, a piece of cardboard, even a fingernail. This is the method chosen for the project described on these pages.

The third method works rather like a carbon copy. Place a sheet of paper over the inked surface and make a line drawing on the top surface of the paper using a sharp implement such as a ballpoint pen or a hard pencil. When you lift the paper, the inked image is "printed" on the reverse side.

This technique works best with a subject which has strong, organic shapes. A figure study is an ideal choice, as are flowers, trees, animals, skies and water. When you draw into the ink, make the lines bold and clear-cut to compensate for the fact that some of the ink closes over the lines when the paper is being rubbed to transfer the image. Try to work on a fairly large scale, because the movement of the hand must not be restricted – draw with strong, sweeping movements from the elbow or shoulder.

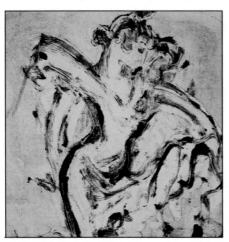

This is an example of a "positive" monotype, in which the image is painted on a glass slab with printing ink or oil paint. A print is taken by laying a sheet of paper over the slab and by gently rubbing the back of the paper with the hand.

FEMALE FIGURE

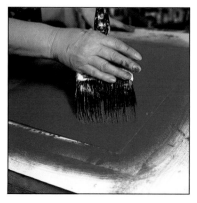

1

Squeeze out about 2.5cm (1in) of cobalt blue printing ink onto the printing surface, mixing it with a little turpentine to make it more malleable. Use a lino-cutting roller or a large decorator's brush to spread the ink over the printing surface. The ink dries quite quickly, so complete this initial stage as fast as you can.

Materials and Equipment

• SHEET OF GLASS OR SMOOTH METAL AT LEAST AS LARGE AS THE INTENDED PRINT • COBALT BLUE PRINTING INK OR OIL PAINT • LINO-CUTTING ROLLER OR LARGE DECORATOR'S BRUSH • SCRAP PAPER • SHEET OF THIN CARTRIDGE (DRAWING) PAPER • COTTON RAG • TURPENTINE OR WHITE SPIRIT (PAINT THINNERS) • MASKING TAPE

2

Blot off any excess ink by laying a piece of scrap paper on the surface and rubbing the back of it. Select a pointed instrument to draw with – you can even use a fingernail – and make your drawing directly on the inked surface.

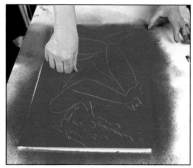

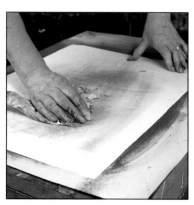

3

To print the image, carefully lay a thin sheet of cartridge (drawing) paper over the inked surface, avoiding any movement once the paper has touched the surface. Force the ink into the paper by rubbing the back of it with a rag dampened with turpentine.

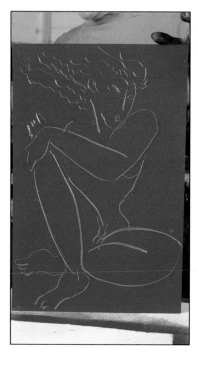

4

Carefully peel the print away from the surface by lifting it slowly from one corner. Attach it to a board with masking tape and leave to dry. The finished monotype has the vigour and spontaneity of a direct sketch, yet it also contains graphic qualities found only in a print.

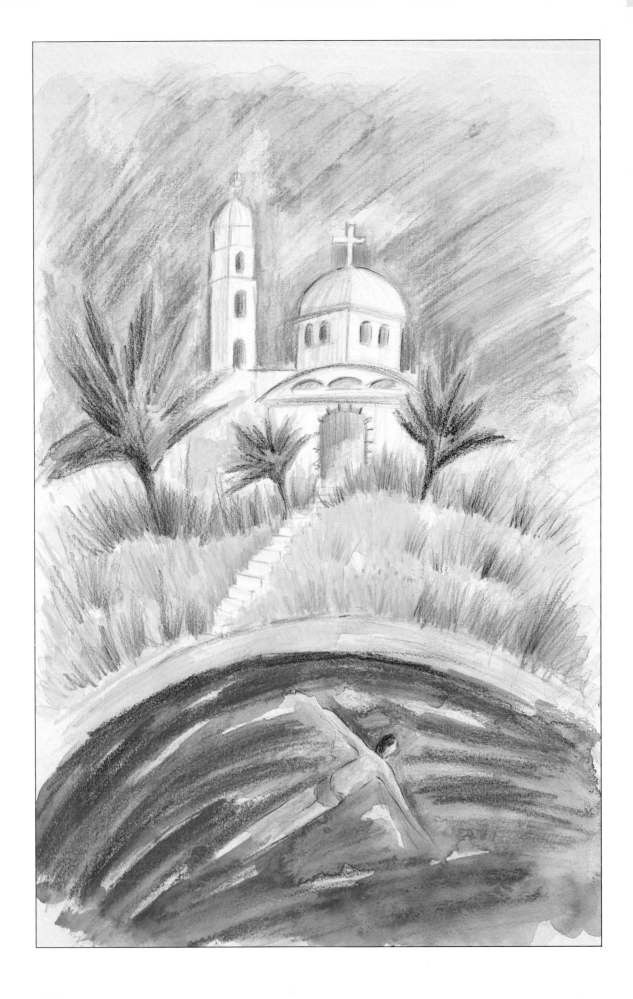

Technique

8

USING WATER-SOLUBLE PENCILS

There is a wide range of coloured pencils and crayons on the market, and in recent years this medium has become increasingly popular with fine artists as well as graphic designers. Water-soluble pencils, which can be used as both a drawing and a painting medium, are clean, quick and portable, and ideal for outdoor sketching.

In keeping with the Mediterranean subject, this water-soluble pencil drawing of a garden in Greece plays sun-shine yellows against clear blues to produce a vibrant effect. Multi-layered washes and strokes are used to develop form and texture.

~

Annie Wood
The Pool
48 x 33cm (19 x 13in)

~

How To Use Water-Soluble Pencils

Water-soluble pencils are a cross between coloured pencils and watercolour paints. You can apply the colour dry, as you would with an ordinary coloured pencil, and you can also use a soft watercolour brush dipped in water to loosen the pigment particles and create a subtle watercolour effect. When the washes dry, you can then add further colour and linear detail using the pencils dry again. This facility for producing tightly controlled work and loose washes makes water-soluble pencils very flexible.

After lightly applying the required colours with hatched strokes, work over the colours with a soft brush and a little clean water to blend some of the strokes and produce a smoother texture. (This takes a little practice; if you use too much water the paint surface will become flooded and blotchy; too little will not allow for sufficient blending of the colours.) The water will completely dissolve light pencil strokes, blending the colour until it looks similar to a watercolour wash. Heavy pencil strokes will persist and show through the wash.

Apply the water gently – do not scrub at the paper with the brush as you want to keep the colours fresh and bright. Rinse the brush every now and then to make sure you are working with clean water, otherwise the colours may become tainted.

Interesting textures can be created by building up the picture with multiple layers of dry pigment and water-dissolved colour. When adding dry colour over a dissolved base, however, the paper must first be completely dry; if it is still damp, it will moisten the pencil point and produce a blurred line, and it may even tear.

Suitable surfaces for water-soluble pencil work are either a smooth illustration board, or a good-quality watercolour paper or medium-grain drawing paper, which should be stretched and taped to a board first.

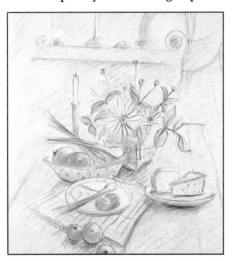

Water-soluble pencils have a freshness and delicacy that is ideally suited to a subject such as this still life, softly lit by the morning sun.

THE POOL

Materials and Equipment

• SHEET OF 300GSM (140LB) NOT (COLD-PRESSED) SURFACE WATERCOLOUR PAPER, STRETCHED • SOFT PENCIL • WATER-SOLUBLE COLOURED PENCILS: PALE BLUE, WARM YELLOW, DARK BLUE, LIGHT GREEN, DARK GREEN, PINK, PURPLE, ORANGE, LIGHT OCHRE, VIOLET, BLUE-GREEN AND DARK BROWN • MEDIUM-SIZED ROUND WATERCOLOUR BRUSH

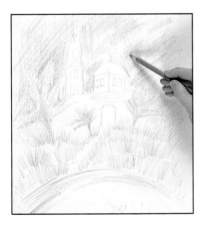

1

Lightly indicate the main elements of the composition with a soft pencil. Fill in the sky area with loosely hatched diagonal strokes of pale blue pencil, leaving some of the white paper showing through. Work lightly to avoid making any hard line. Use a warm yellow pencil for the palm trees and grasses, using upward flicking strokes.

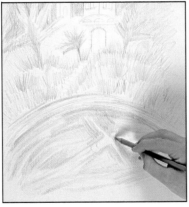

2

Suggest the water in the pool with light strokes of pale blue, again leaving plenty of white paper showing through. Vary the direction of the strokes to suggest the movement on the water's surface created by the swimming figure.

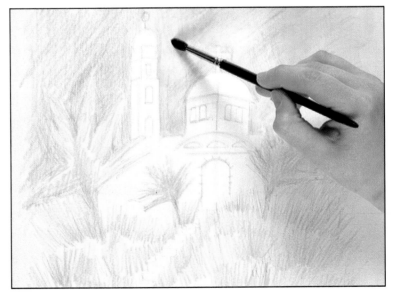

3

Load a medium-sized round brush with water and work it lightly over the sky area to soften and partially blend the pencil lines. Use sweeping, diagonal strokes to give a sense of movement to the sky.

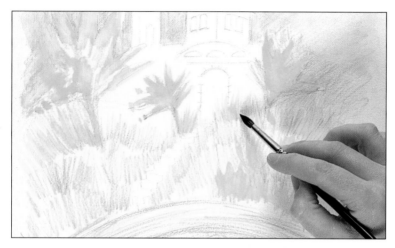

4

Rinse your brush, then apply water to the trees and grasses to blend some of the pencil strokes and create a smoother texture. Don't worry if some of the yellow wash runs into the sky area – it will mix with the blue and form green, giving a suggestion of more foliage in the background. Leave to dry.

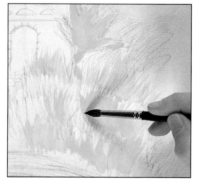

5

When applying the water, work lightly across the drawn lines without rubbing too hard. This releases just enough colour to produce a light wash which does not completely obliterate the linear pencil strokes.

6

Work back into the sky with further diagonal hatched strokes of both pale and dark blue, leaving some areas of wash untouched. With the dark blue pencil, firm up the water with vigorous directional strokes that follow the curved form of the pool. Leave some patches of pale blue to indicate the highlights on the water's surface.

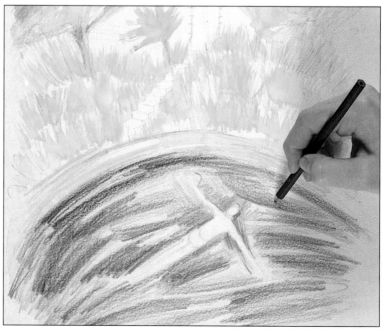

USING WATER-SOLUBLE PENCILS

7

Work into the trees and grasses with short, upward flicking strokes of light and dark green. Also add touches of pink, purple and orange to add colour interest and give a suggestion of heat and bright sunlight. Block in the figure's skin tone with a light ochre pencil, and his swimming trunks with pink. Add further washes of water to pick up and dissolve some of the colour in the pool.

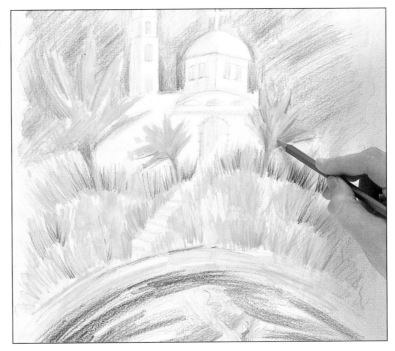

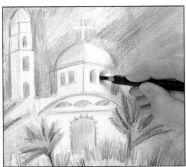

8

Add strokes of dark green to the palm trees and grass. Strengthen the detail on the church, blocking in the door, the windows and the shadows on the walls with strokes of pink and yellow. Then darken the door and windows with overlaid strokes of dark blue and violet.

9

Darken the water with broad strokes of blue-green, wetting some of the strokes to create a sense of movement on the water's surface. Leave to dry, then block in the swimmer's hair with dark brown. Finally, strengthen the outline of the figure with a dark blue pencil.

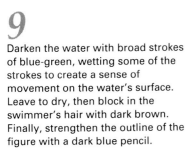

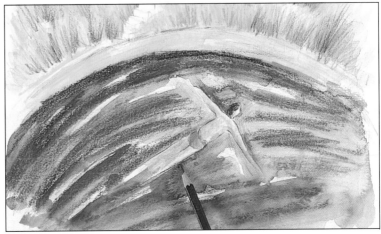

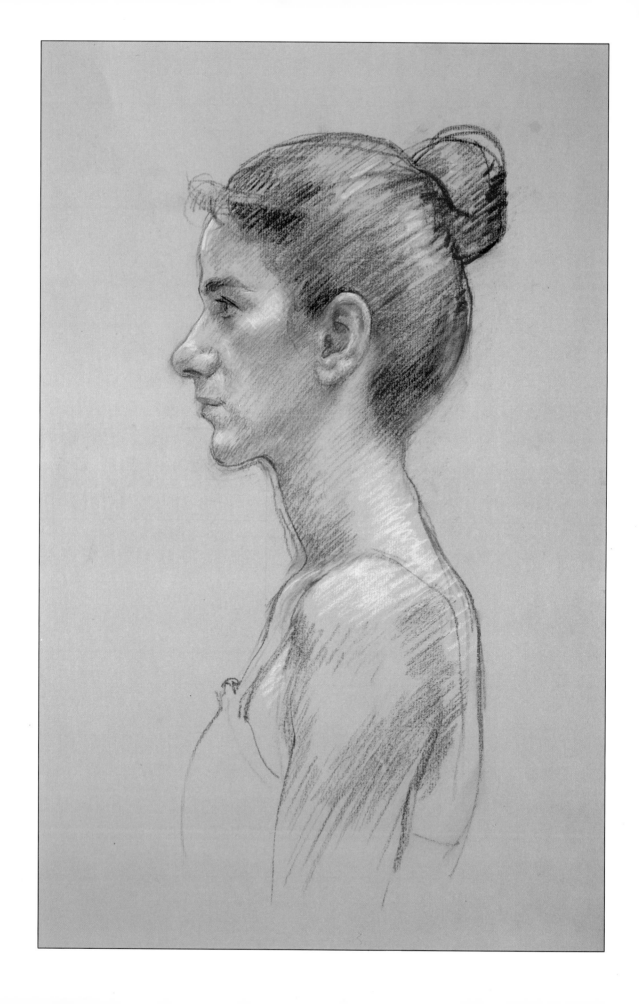

Technique

9

DRAWING ON TINTED PAPER

A drawing done in pastel or conté crayon on tinted paper is very much a marriage of medium and paper. Because areas of the tinted paper show through the drawn marks they play a key role in the overall colour scheme; thus the paper and the drawn lines work in tandem, creating an exciting fusion of texture and colour.

This study of a head in profile was drawn in conté crayon on a warm buff-coloured paper. The paper creates the midtones, while the form of the head and shoulders is modelled with hatched strokes, using earth colours for the darks and white for the highlights. Because the paper itself acts as the mid-tone for the skin and hair, the artist needs only a few colours to build up a fully developed portrait.

~

Elizabeth Moore
Head Study
51 x 33cm (20 x 13in)

~

USING TINTED PAPERS

There are two ways in which a tinted paper surface can function in a drawing. The first is as a mid-tone, from which the artist can assess extremes of light and shade. The second is as a unifying element, its colour linking the various areas of the composition to form a unified image.

Drawing papers come in such a wide range of colours that it can be difficult to choose the best one for your needs. Start by deciding whether you want the paper's colour to harmonize with the subject or to provide a contrast. Then decide whether the colour should be cool, warm or neutral. For example, artists often favour a paper with a warm earth colour to accentuate the cool greens of a landscape, or a neutral grey paper to enhance the bright colours of a floral still life. Finally, decide whether you want a light, medium or dark-toned paper. In general, mid-toned papers give the best results. They allow you to judge both the light and dark tones in your drawing accurately, and they provide a quiet, harmonious back-drop to most colours. It is generally best to avoid strongly coloured papers since they will fight with the colours in the drawing. If you are in any doubt, choose muted colours such as greys, greens and browns.

Conté crayons are similar in effect to charcoal but they are harder and therefore can be used for rendering fine lines as well as broad tonal areas. Although conté crayons are now available in a wide range of colours, many artists still favour the restrained harmony of the traditional combination of black, white and the three earth colours – sepia, sanguine and bistre. These colours, with their warm, tender and soft tones, are especially suited to portrait and figure drawings. Expressive lines can be drawn with the crayon point while varied tones are possible using the side of the crayon, thus providing an exceptional way of suggesting form, light, colour and volume. The traditional colours also give an antique look reminiscent of the chalk drawings of Leonardo da Vinci, Michelangelo, Rubens and Claude.

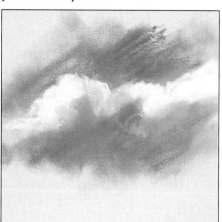

This cloud study is worked in chalk on tinted paper. The paper forms a useful mid-tone from which to work up to the lights and down to the darks.

HEAD STUDY

Materials and Equipment
• SHEET OF BEIGE CANSON PAPER • CONTÉ CRAYONS: SEPIA, INDIAN RED, WHITE, RAW UMBER AND BLACK • SPRAY FIXATIVE

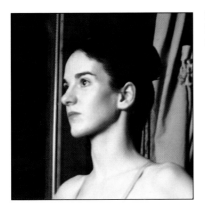

Left: Strong directional light coming from the left of the model helps to describe the volumes of the head.

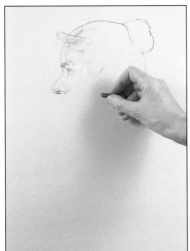

1

Using the sepia crayon, start by sketching the main outlines of the head and positioning the features. Use light, feathery strokes so that you can build up the darker tones later without clogging the surface of the paper.

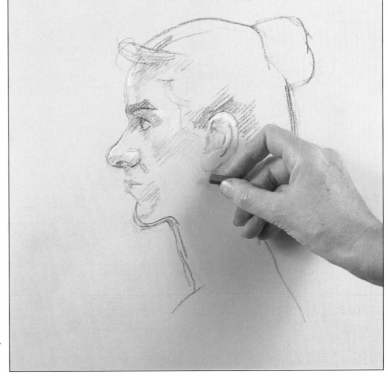

2

Continue to define the head and features and the line of the neck and shoulders. To establish the main planes of the face, begin shading in the darkest tones with light hatching, using the sepia crayon. Indicate the mouth and cheeks with Indian red.

3

Continue defining the tones and colours on the face with sepia and Indian red. Indicate the highlights on the forehead, upper cheek and chin with white. Use stronger tones of sepia and Indian red to model the inner ear. Build up the shadowed areas of the hair with overlapping strokes of sepia, allowing the buff paper to show through. This shading helps to define the underlying form of the head. Hatch in the shadow on the neck.

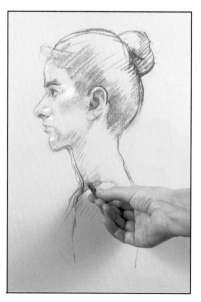

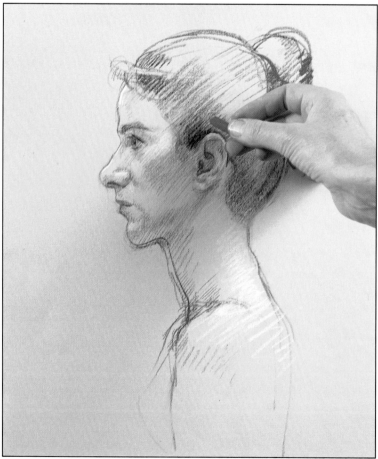

4

Strengthen the modelling on the face and neck with fine hatching to produce carefully graded tones. Use sepia, raw umber and Indian red for the shadows and white for the highlights. As you draw, constantly relate shapes and volumes to one another rather than drawing one part in detail and then moving on to the next. Use stronger tones of sepia and Indian red to model the inner ear, and solid strokes of white for the highlights. Darken the hair with strokes of black.

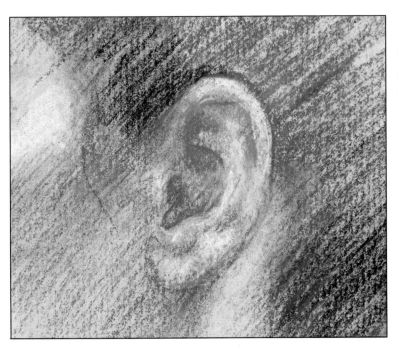

Left: The whorls and curves of the ear are quite complex, but the trick is to render them as simply as possible, paying close attention to the shapes of the shadows and highlights.

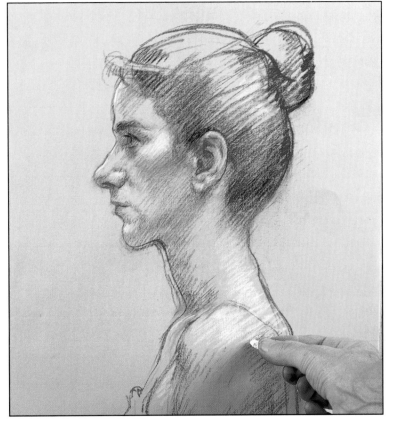

5

Briefly sketch in the shadows and highlights on the neck and shoulders with sepia and white. The head is more fully modelled as this is the focal point of the picture.

Observe how the tinted paper shows through the drawing in places, suggesting the mid-tone between dark and light. These patches of bare paper also help to breathe air into the drawing, enhancing the delicacy of the drawn lines. Because conté smudges easily, the finished picture should be sprayed lightly with fixative.

Technique
10

INK AND GOUACHE "WASH-OFF"

Ink and gouache "wash-off" is an unusual technique that exploits the properties of waterproof Indian ink and water-soluble gouache paint to produce a negative image in black and white. The results are unpredictable, which is part of the fun, and the finished result is very striking, with textural effects that resemble those of a woodcut or lino print.

Wash-off is most successful with a subject that is essentially linear and decorative, as in this stylized image of a vase of poppies.

~

Ted Gould
Poppies
41 x 36cm (16 x 14in)

~

79

"WASH-OFF" TECHNIQUE

Ink "wash-off" is a simple technique, but it requires careful planning and should not be hurried. In particular, it is vital to ensure that each stage is completely dry before you move on to the next. You will need a sheet of watercolour board or good-quality, heavy watercolour paper, which must be stretched and taped to a board as it will be saturated with water during the wash-off process.

First paint your chosen image or design with thick, white gouache paint – it is essential to use white because a colour would stain the paper and spoil the finished effect. If you find it difficult to see the white gouache against the white paper, you can stain the paper first with a pale watercolour wash. Apply the paint quite thickly; if it is too thin the ink applied subsequently may mix with the paint.

When the gouache is bone dry, use a large brush to cover the whole paper with an even coat of black waterproof Indian ink. When applying the ink, make sure your brush is well loaded because if you try to go over an area again the gouache will begin to mix with the ink and the final effect will be spoiled. Use a large, soft brush and work quickly, "floating" the ink on – too much pressure will cause the gouache beneath to dissolve and mix with the ink.

When the ink is completely dry, hold the painting under cold, running water. This causes the soluble gouache paint to dissolve and it is washed off; the areas of dried ink covering the gouache disintegrate and are washed off at the same time, but the ink in the unpainted areas remains. The result is a white, "negative" image on a black background.

POPPIES

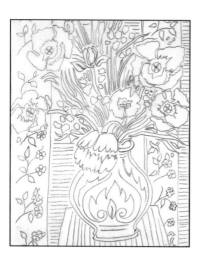

1
Make a careful outline drawing of the subject in pencil.

Materials and Equipment
• SHEET OF NOT (COLD-PRESSED) SURFACE WATERCOLOUR BOARD OR HEAVY STRETCHED WATERCOLOUR PAPER • HB PENCIL • MEDIUM-SIZED ROUND SOFT BRUSH • PERMANENT WHITE GOUACHE PAINT • LARGE SOFT BRUSH • BLACK WATERPROOF INDIAN INK • SMALL SOFT SPONGE (OPTIONAL)

2

With a medium-sized round soft brush and permanent white gouache, carefully paint in those areas which are to remain white in the final image. Of the various whites available, permanent white is the best as it has the thickness and body required for this technique. Paint the lines on the table and on the screen in the background with drier, thinner paint so as to create broken brush strokes. Leave to dry completely.

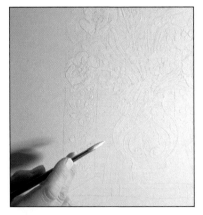

3

Using a large soft brush, paint Indian ink over the entire picture surface, starting at the top and applying the ink in broad, horizontal bands. Leave to dry.

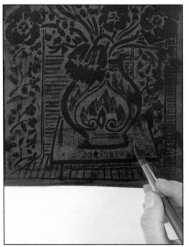

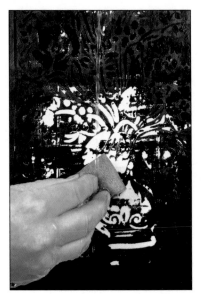

4

When the ink is bone dry, hold the board under running water. The gouache will start to dissolve and come away from the board, lifting the ink covering it. Any stubborn areas can be coaxed off gently with a soft brush or sponge. The black ink that was not painted over gouache remains intact. Leave to dry flat.

Right: This close-up detail of the finished image shows the subtle nuances of line and tone that can be obtained by varying the thickness of the gouache applied initially. Here, a smooth, thick layer of gouache was applied on the flowers, while thinner, drier paint was used for the pattern on the vase.

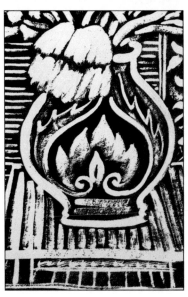

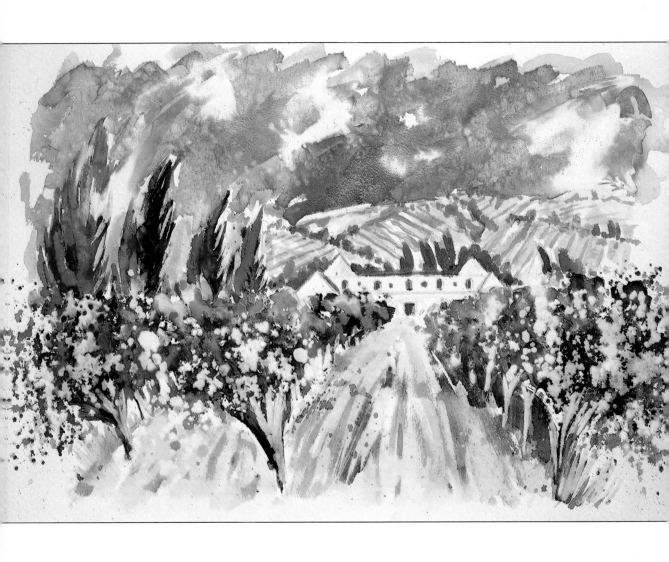

Technique
11

INKS, BLEACH, SALT AND SUGAR

Coloured inks, like watercolour paints, are a fluid medium capable of producing exciting, spontaneous effects. Exploiting the medium to the full, the artist has employed several innovative techniques in this bold interpretation of a landscape in Tuscany.

In order to recreate the energy inherent in this dramatic landscape, the artist worked linear strokes of diluted household bleach into the brightly coloured inks, spattered ink and bleach onto the trees to give them a sense of movement, and sprinkled a generous amount of salt and sugar into the washes in the sky area to create intriguing textures.

~

Annie Wood
Tuscan Landscape
48 x 64cm (19 x 25in)

~

USING INKS WITH OTHER MATERIALS

Salt or sugar sprinkled into a wet wash of ink produces exciting textures and effects. The granules soak up the pigment and, when the ink is dry, they can be brushed off, leaving a delicate pattern of pale, crystalline shapes where the salt or sugar granules have absorbed the ink around them. These shapes can be used to suggest all manner of natural textures, such as falling snow or weathered rocks and stones.

A variation on this technique is to apply both salt and sugar more heavily to the wet ink wash. Instead of brushing the granules away when the ink has dried, they are left in place on the paper. As the ink dries the granules of salt and sugar cake together and create an attractive, grainy surface texture.

In the project starting on page 47, a dry layer of fountain pen ink was drawn into with a cotton bud (swab) dipped in household bleach to produce "negative" shapes and outlines. A similar technique is used in this project, this time using diluted bleach brushed and spattered onto the ink to create interesting textures. Always use fountain pen ink as neither water-proof nor soluble drawing ink will bleach out successfully.

When you are mixing up the bleach solution, add water a little at a time and test it on a dry wash of ink on scrap paper to check that it is of the right strength. Some brands of household bleach are stronger than others, and only those that contain chlorine are suitable for this technique.

When using a bleach solution it is advisable to choose an old paintbrush which must have synthetic hairs, as the bleach would destroy natural ones. *Note: Always work in a well-ventilated room and avoid getting the solution in your eyes or on your skin.*

The final technique used in this project is spattering. This is another excellent method of simulating rough and pitted textures, and it also lends movement and spontaneity to the drawing. In this project spattering has been employed to suggest the blossom on the trees in the foreground. To create spatter, load a round watercolour brush with ink and hold it horizontally above the paper. Tap the brush handle with your outstretched forefinger to release a shower of small drops onto the paper.

Here a combination of brightly coloured inks, worked into with bleach and sprinkled with sugar and salt, succeeds in evoking the steamy atmosphere of a Brazilian rain forest.

TUSCAN LANDSCAPE

Materials and Equipment

• SHEET OF SMOOTH CARTRIDGE (DRAWING) PAPER OR WATER-COLOUR PAPER, STRETCHED • SOFT PENCIL • SMALL ROUND WATERCOLOUR BRUSH • FOUNTAIN PEN INK: BLACK AND TURQUOISE • WATER-SOLUBLE DRAWING INKS: BLACK, TURQUOISE, CARMINE, SUNSHINE YELLOW, EMERALD GREEN AND BRILLIANT GREEN • MEDIUM-SIZED FLAT WATERCOLOUR BRUSH • HOUSEHOLD BLEACH • AN OLD, SYNTHETIC-HAIR WATERCOLOUR BRUSH (SMALL ROUND) FOR APPLYING BLEACH • TABLE SALT • GRANULATED SUGAR

1

With the paper stretched and taped to a board, lightly sketch in the main elements of the composition with a soft pencil.

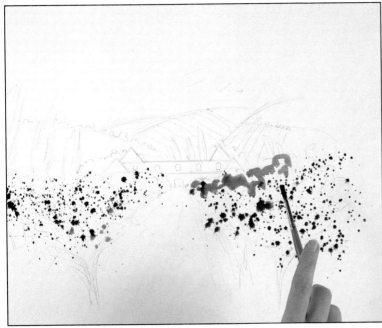

2

Now apply some random spattered dots to the foreground trees. Load a small round watercolour brush with black fountain pen ink. Lay the board flat on the work surface. Hold the brush as shown, about 5cm (2in) above the paper, and tap it gently with a forefinger to release a shower of dots onto the upper parts of the trees. If you wish, mask off the rest of the drawing area with paper to catch any stray dots of ink.

3

Working quickly before the ink spatter dries, rinse the brush in water and shake off the excess. Then work back into the spatter with the damp brush, blending together some of the spattered dots to create an impression of foliage. Draw the tree trunks, then draw the cypress trees on the left of the picture with slightly diluted ink.

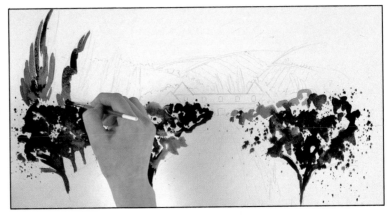

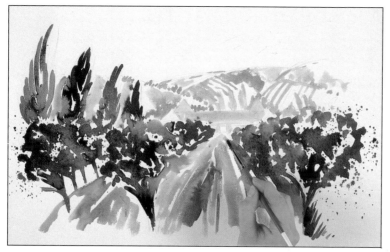

4

Mix one part black drawing ink to two parts water and use this to draw in the receding lines of the foreground field and the farmhouse. Use much smaller marks to suggest the fields and trees in the background. Notice how the tones in the foreground are darker than those in the background, conveying an impression of recession and distance.

5

Paint the sky using turquoise fountain pen ink and a medium-sized flat brush. Sweep the ink on quite randomly, varying the tones of blue and leaving patches of white paper showing through.

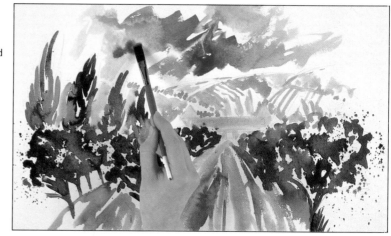

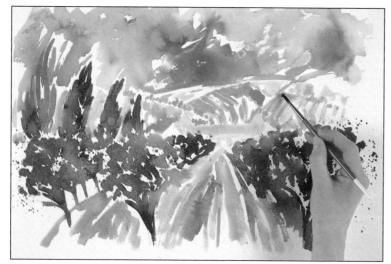

6

Switching back to the round brush, apply touches of thinly diluted turquoise ink to the distant fields and trees.

7

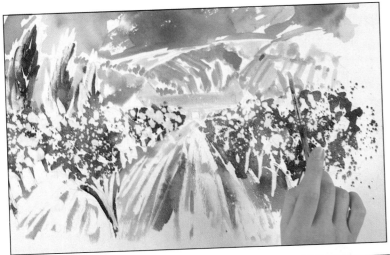

In a small glass jar mix one part household bleach to two parts water. With a small round synthetic-hair watercolour brush, spatter the bleach solution onto the foliage of the foreground trees as you did with the ink in step 2. Use the brush to blend together some of the dots and draw the tree trunks. Apply a few streaks of bleach to the foreground field and the cypress trees.

8

Loosely work into the sky area with the bleach solution to create an impression of scudding clouds. Bleach out most of the farmhouse, leaving the windows and some linear details. Leave to dry.

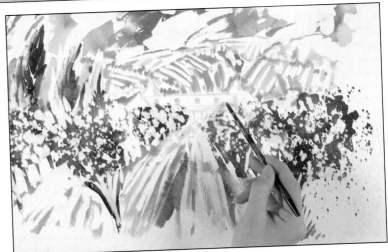

9

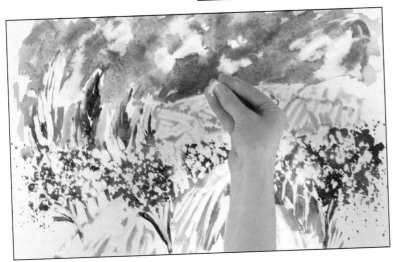

Still using the old paintbrush, because of the bleach on the paper, work into the sky area again with loose brush strokes of fairly diluted turquoise ink. While the ink is still wet, sprinkle it first with salt, then with sugar. The salt soaks up some of the pigment, and the salt and sugar cake together on the surface. The result is an interesting, mottled texture.

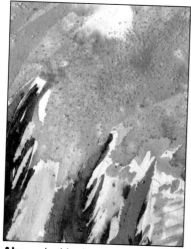

Above: In this close-up detail of the sky you can see the granular effect created by the salt and sugar.

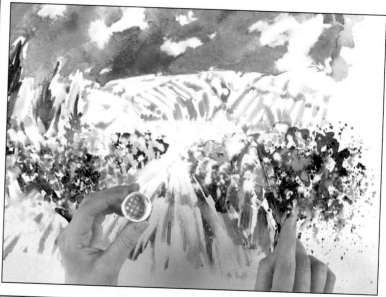

10

With carmine drawing ink and the old paintbrush, work into the trees once more with the spatter-and-blend technique.

11

While the carmine ink is still wet, repeat step 10 with turquoise ink and reinforce the tree trunks. The bleach applied earlier merges with the pigments and creates pools of luminous colour. Leave the drawing to dry.

INKS, BLEACH, SALT AND SUGAR

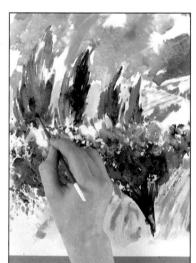

12

Apply a loose wash of sunshine yellow drawing ink over the fields, slightly diluting the colour in the distance. Leave to dry, then paint the cypress trees with a mixture of emerald green and brilliant green drawing inks. Use the same colour, diluted to a pale tint, for the hedges and trees in the distance.

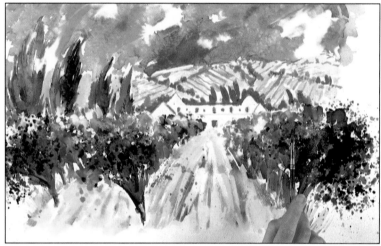

13

Strengthen the details on the farmhouse with diluted black drawing ink. Darken the three trees in the immediate foreground with further spatters of black and turquoise ink, diluting the ink with water in places to obtain tonal variation. Leave to dry.

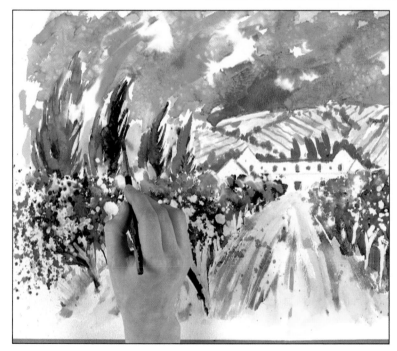

14

Finally, spatter the foreground trees once more with the bleach solution and work a few lines into the cypress trees. Leave to dry flat.

Technique

12

SGRAFFITO

The technique of sgraffito – using a sharp tool to inscribe patterns into a surface – goes right back to the Stone Age. The Romans developed the technique further, layering pigmented plaster on the walls of their villas and then incising designs through it to reveal the layers of colour beneath.

In this stylized drawing of a Punch and Judy show the artist has drawn the image with brightly coloured wax crayons, applied a layer of black crayon over the colours and then scratched lines into the top layer with a sharp point. The sgraffitoed lines create a fascinating surface texture and add dimension to an otherwise flat area of colour.

~

Ted Gould
Punch and Judy
24 x 20cm (9½ x 8in)

~

SGRAFFITO TECHNIQUES

The word "sgraffito" is derived from the Italian word *graffiare*, meaning "to scratch", and refers to a method of scratching or scraping through a layer of colour to expose a different colour or colours beneath. As well as creating interesting surface textures in a drawing, sgraffito can be used to simulate actual textures such as the grain of wood, the papery skin of an onion, or blades of grass.

Sgraffito is very effective when used with layered pastel, wax crayon or coloured pencil. A heavy application of colour is rubbed onto the paper to produce a dense, even layer of colour. It is important that the surface is thick enough to scrape into successfully. A second colour is then applied over the first, this time not rubbed in. It is now possible to scratch fine etched lines through the top layer to reveal the colour beneath. Fascinating results can be achieved by

scratching through to the layers of colour beneath.

Any sharp instrument can be used for sgraffito – a craft knife or razor blade, scraperboard tools, a nail, the point of a metal nail file, even a finger-nail. Experiment with different scraping tools to discover the variety of textures and patterns that can be obtained. For example, the point of a nail creates a delicate line whereas the side of a craft knife blade makes a broad stroke.

For sgraffito drawings you will need a good-quality paper heavy enough to withstand the bladework without tearing. Heavy cartridge (drawing) paper or Bristol board with a smooth surface are good choices. As you scratch into the colour, move the blade in one direction only – scratching back and forth damages the paper. Use fast, light strokes and do not press too hard.

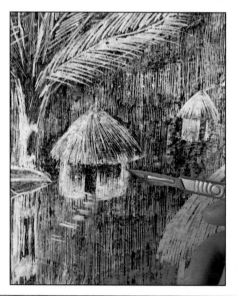

Use a scalpel or scraperboard tool if you want to make sharp, clean lines. Use fast, light strokes and work in one direction only.

SGRAFFITO

PUNCH AND JUDY

1

Make an outline drawing of the subject in pencil, then outline each area of the drawing with its relevant colour using wax crayons.

2

Start filling in the outlines with blocks of colour – here the pinks and reds are being applied. Apply the colours in a dense, thick layer, rubbing the crayons well into the paper surface. Remember that the colours will appear less intense after they have been scratched into. You may find it useful to place a sheet of paper under your drawing hand as you work, to prevent smudging.

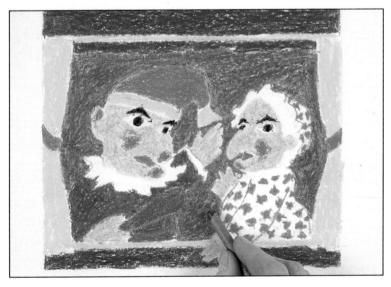

3

Continue blocking in the colours. Use blue for Punch's shirt; dots of green for Judy's dress and hat; yellow for the curtains and the trims on Punch's hat; purple for the border and brown for Punch's truncheon. Apply white to the eyes and the ruffs on the clothing, and draw the eyes and eyebrows with black. Fill in the background with brown.

4

Cover the whole picture area with a layer of black crayon. Apply the colour less densely this time, so that the drawing beneath remains just visible.

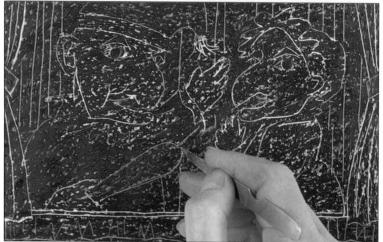

5

Use the sharp end of a metal nail file to retrieve the original outlines of the drawing by scratching through the layer of black to reveal the colours below. As you work, brush away the excess particles with a soft brush.

6

Continue scratching back into the drawing using loose hatched and crosshatched strokes for the flat areas such as the faces. Scratch a striped pattern into Punch's shirt and diagonal hatched lines over Judy's dress and bonnet. Finally, scratch some decorative lines into the curtains, the background and the border. This detail shows how the underlying colours are revealed, as you scratch through the layer of black, and the drawing now has a lively surface texture.

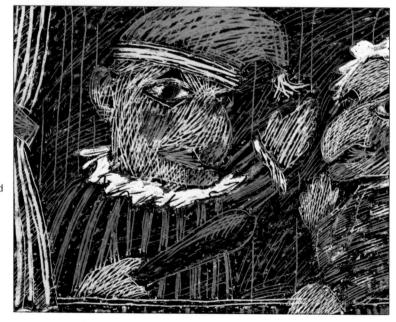

Suppliers

Suppliers

Winsor & Newton
painting and drawing materials
51 Rathbone Place
London W1P 1AB
Tel: 071–636 4231

George Rowney & Co Ltd
painting and drawing materials
12 Percy Street
London W1A 9BP
Tel: 071–636 8241

Russell & Chapple Ltd
general art supplies
23 Monmouth Street
London WC2H 9DD
Tel: 071–836 7521

L Cornelissen & Son Ltd
general art supplies
105 Great Russell Street
London WC1B 3LA
Tel: 071–636 1045

John Mathieson & Co
general art supplies
48 Frederick Street
Edinburgh EH2 1HG
Tel: 031 225 6798

Copystat Cardiff Ltd
general art supplies
44 Charles Street
Cardiff CF1 4EE
Tel: 0222 344422
Tel: 0222 566136 (mail order)

The Two Rivers Paper Company
hand-crafted papers
Pitt Mill
Roadwater
Watchet
Somerset TA23 0QS
Tel: 0984 41028

Falkiner Fine Papers Ltd
watercolour and drawing papers
75 Southampton Row
London WC1B 4AR
Tel: 071–831 1151

Frank Herring & Sons
easels, sketching stools, palettes
27 High West Street
Dorchester
Dorset DT1 1UP
Tel: 0305 264449

Art Supply Warehouse
general art supplies (mail order)
360 Main Avenue
Norwalk
CT 06851
USA
Tel: (800) 243–5038

Artisan/Santa Fe Art Supplies, Inc
general art supplies (mail order)
Canyon Road
Santa Fe
NM 87501
USA

Creative Materials Catalog
general art supplies (mail order)
PO Box 1267
Gatesburg
IL 61401
USA
Tel: (800) 447–8192

Hofcraft
general art supplies (mail order)
PO Box 1791
Grand Rapids
MI 49501
USA
Tel: (800) 435–7554

Pearl Paints
general art supplies (mail order)
308 Canal Street
New York
NY 10013–2572
USA
Tel: (800) 451–7327

Manufacturers

Winsor & Newton
painting and drawing materials
Whitefriars Avenue
Wealdstone
Harrow
Middx HA3 5RH
Tel: 081–427 4343

Daler-Rowney Ltd
painting and drawing materials
PO Box 10
Southern Industrial Estate
Bracknell
Berks RG12 8ST
Tel: 0344 42621

Berol Ltd
pens, pencils, markers etc
Oldmedow Road
King's Lynn
Norfolk PE30 4JR
Tel: 0553 761221

INDEX

PICTURE CREDITS
The author and publishers would like to thank the following for permission to reproduce additional photographs:

The Bridgeman Art Library: pages 6 (Christies, London), 7 (British Museum), 9 (Private Collection/© David Hockney, 1973). **Visual Arts Library:** page 8 (Groningen Museum).